*W*hisper of the *M*use

Criticism may in a sense be compared to photography.
Exceptional in the critical as in the photographic art are those
productions which—like the surprising and magnificent pictorial
photographs of Mrs. Cameron to be seen at Colnaghi's—
well-nigh recreate a subject; place it in novel, unanticipable
lights; aggrandize the fine, suppress or ignore the petty; and
transfigure both the subject-matter, and the reproducing process
itself, into something almost higher than we know them to be.
This is the greatest style of photography or criticism; but it
undoubtedly partakes of the encroaching or absorptive nature,
such as modifies if it does not actually distort the objects
represented, and insists as much upon our thinking as much
of the operator, and of how *he has been operating, as of those*
objects themselves.

—William Michael Rossetti,
Fine Art Chiefly Contemporary (1867)

Whisper of the Muse

The Overstone Album
& Other Photographs by
Julia Margaret Cameron

Essay by Mike Weaver

The J. Paul Getty Museum, Malibu

1986

Library of Congress Cataloging-in-Publication Data

Cameron, Julia Margaret Pattle, 1815–1879.
 Whisper of the muse.

 Catalog of an exhibition presented at the Getty
Museum, Sept. 10–Nov. 16, 1986.
 Bibliography: p.
 Includes index.
 1. Photography, Artistic—Exhibitions. 2. Cameron,
Julia Margaret Pattle, 1815–1879—Exhibitions.
3. J. Paul Getty Museum—Photograph collections—
Exhibitions. 4. Photograph collections—California—
Malibu—Exhibitions. I. J. Paul Getty Museum.
II. Title.
TR647.C3544 1986 779'.092'4 86-20939
ISBN 0-89236-088-7

Jacket: Julia Margaret Cameron (British, 1815–1879),
The Whisper of the Muse/Portrait of G. F. Watts (Over-
stone fol. 75r), 1865. H: 26.1 cm (10¼"); W: 21.5 cm
(8⁷⁄₁₆"). Malibu, The J. Paul Getty Museum 84.XZ.186.
The circular motif debossed on the cloth cover repro-
duces that carved on the Overstone Album's original
board cover.

CONTENTS

Foreword *John Walsh* 9

Preface *Weston J. Naef* 11

A Divine Art of Photography *Mike Weaver* 15

Documents 61

Checklist of Overstone Images 69

Index of Proper Names & Photograph Titles 99

Selected Bibliography 103

LIST OF PLATES

1. Julia Margaret Cameron, *G. F. Watts,* 1864. Overstone fol. 38r. 19

2. J. M. Cameron, *Rev. J. Isaacson,* 1864. Overstone fol. 60r. 20

3. J. M. Cameron, *Colonel Lloyd Lindsay,* 1865. Overstone fol. 80r. 27

4. J. M. Cameron, *Grace thro' Love,* 1865. Overstone fol. 16r. 28

5. J. M. Cameron, *The Double Star,* 1864. Overstone fol. 58r. 35

6. J. M. Cameron, *The three Marys,* 1864. Overstone fol. 84v. 36

7. J. M. Cameron, *Prayer and Praise,* 1865. Overstone fol. 72r. 43

8. J. M. Cameron, *Long-suffering,* 1865. Overstone fol. 50r. 44

9. J. M. Cameron, *"Flos and Iolande,"* 1864. Overstone fol. 53r. 51

10. J. M. Cameron, *Thomas Carlyle,* 1867. 84.XM.443.17. 52

FOREWORD

This book appears on the occasion of an exhibition of Julia Margaret Cameron's "divine art," the first exhibition from the Museum's recently formed collection of photographs and therefore a great moment in our short, eventful history.

Mrs. Cameron's photographs make a fitting debut for us. Two years ago, when I wanted to persuade the Trustees that the Museum ought to collect photographs, I gave them a survey of the history of the medium, with slides of the most appealing examples I could find to demonstrate the highest aspirations of nineteenth-century photography. I remember the spontaneous murmur when I showed one of Mrs. Cameron's portraits of Thomas Carlyle. For our Trustees, as for anyone who might have doubted the sheer power of photographs, no words were needed. Carlyle himself had said, "It is as if suddenly the portrait began to speak, terrifically ugly and woebegone."

Anyone who wonders about the place of photographers in the succession of artists since the Renaissance will have little trouble locating Mrs. Cameron: her subtle lighting, complex characterizations, and telling compositions reveal a line of descent from Tintoretto through Rembrandt down to her friends and contemporaries, Watts and the Pre-Raphaelites. Mrs. Cameron's pictures make an ambitious claim for photography. Thanks in part to the force of her example, that claim has largely been upheld in the century since she died.

It is astonishing to realize that one of the best places to study Cameron's life and work is now Los Angeles. The starting point is the Aubrey Ashworth Taylor collection of thirty-five Cameron photographs, acquired years ago by the Special Collections Division of the UCLA Research Library. The Getty Museum bought some 225 Cameron photographs in 1984, and the Getty Center for the History of Art and the Humanities has just acquired an archive of the letters and papers of the Cameron family.

Knowing that we can never do justice to our collection of some sixty thousand photographs in the restricted space of our present building, we are joining forces with other museums in various projects. We are pleased that the show at the Museum of some forty of Mrs. Cameron's photographs is being staged simultaneously with two others in the area: one at UCLA and the other at Loyola Marymount University. To the latter we have lent the photographs Mrs. Cameron presented to Lord Overstone that are reproduced in this book.

There will be five exhibitions a year until 1993, when the Department of Photographs moves to more ample quarters in the new Getty Museum in Brentwood. Some of these shows will be monographic, others thematic; some will be the work of Weston Naef and his staff, others that of visiting scholars and consultants. A series of books is planned, usually in connection with these exhibitions, in order to foster scholarship in a field to which we hope to contribute much in the years to come.

John Walsh
Director

PREFACE

In August 1865 Julia Margaret Cameron made an extraordinary gift of 111 of her photographs to Lord Overstone, a gentleman of great distinction who had been a schoolmate of her husband's at Eton. The motivations behind this gift are revealed by Mike Weaver in the essay that follows. We are very fortunate to have secured the collaboration of Dr. Weaver in this endeavor, since he has contributed more than any other single individual to the unraveling of Mrs. Cameron's sources and influences. Dr. Weaver first published his highly original interpretations in the catalogue he prepared for an exhibition of Mrs. Cameron's work organized by the John Hansard Gallery, University of Southampton. He presented these ideas in his recent survey of Mrs. Cameron's art which was published under the title *Julia Margaret Cameron, 1815–1879* (London and Boston: New York Graphic Society and Little, Brown and Company, 1984). The chronology, bibliography, and notes found in the latter publication are useful supplements to the information included in the present volume.

By way of a preface to Dr. Weaver's remarks, let us be certain that we understand the character and importance of Mrs. Cameron's gift to Lord Overstone, and some of the reasons that led her to take up photography at the age of forty-eight in 1863. First, we must understand that when a photographer, or any artist, makes a gift of more than one hundred works of art to another person or to an institution, it represents a considerable personal sacrifice. The amount of time and money required in the mid-nineteenth century to create a single photograph was measured in hours, not in minutes, as it often is today. A hundred of Mrs. Cameron's photographs therefore represent hundreds of hours of work, all done by hand and without the assistance of the labor-saving machines and chemicals that are modern inventions. In addition to her labor, there were significant out-of-pocket expenses for the raw materials, including the silver and gold bullion that were reduced chemically by the photographer in her studio to create the sensitizing and toning liquids. It is estimated that each albumen print required up to two hours of time for exposing, washing, toning, drying, and mounting. Mrs. Cameron did this work herself and often indicated this in writing below her prints.

The 110 prints Mrs. Cameron carefully selected for Lord Overstone from her first two years of work were mounted on sheets of paper. She inscribed her name on most of them and assigned a title to each which would have been meaningful to someone with Lord Overstone's particular interest in the arts. The individual sheets were then bound as an album—with a dedication and list of contents that were handwritten by Mrs. Cameron—and mounted between covers made of wood. The front cover was carved with an ornamental design. Lord Overstone's collection of Cameron photographs saw the same fate as many mid-nineteenth-century photographs and was not treated with the respect it deserved by subsequent owners. The album was evidently housed in a damp place. Its covers have since warped, the binding materials have deteriorated, and the leaves themselves have been discolored by bacterial infestations, thus destroying the sumptuous appearance the object would have had when it was presented to Lord Overstone. The silver and gold content of the photographs has saved them from serious deteriora-

tion. Some, however, show signs of edge fading and oxidation which can be attributed to insufficient washing and inadequate toning of the prints.

The album Mrs. Cameron presented to Lord Overstone was the fourth of approximately one dozen collections that were similarly mounted, inscribed, and presented to persons whom Mrs. Cameron admired and vice versa. In 1863 she presented to her sister Maria a group that also includes photographs by O. J. Rejlander, who apparently influenced Mrs. Cameron, and by Lewis Carroll. In February 1864 she gave a set of photographs to G. F. Watts (Rochester, George Eastman House), and the following November she made a similar gift to Sir John Herschel (Bradford, National Museum of Photography, Film and Television). Two important sets of her photographs are preserved in Los Angeles: the Overstone gift, made in August 1865, and a set of full-plate prints given to Aubrey Ashworth Taylor in September 1869. Among the other recipients of albums by Mrs. Cameron were Beta Murray, Sir Coutts Lindsay, the Crown Prince of Prussia, Lord Bury, Anne Thackeray Ritchie, her gardener, and members of her family. It may be assumed that the recipients of these valuable collections were given them because Mrs. Cameron believed her friends had special sympathy or understanding for her art, because she wished to acknowledge some form of material or emotional assistance, or for both of these reasons, as was true in Lord Overstone's case.

Does the relatively large number of presentation albums she prepared suggest that Mrs. Cameron believed her work deserved more public attention than it received from her contemporaries? The answer is probably yes. She is known today to all students of the art of photography as the greatest pictorialist of her day and as the creator of a style that continued to influence experimental photographers in England and America more than a generation after her death. But Mrs. Cameron's genius—and "genius" is the most appropriate word to describe her—was apparently misunderstood by most of her contemporaries. Dr. Weaver's essay takes us back to Mrs. Cameron's own time, evoking her associations with a circle of thinkers and writers including Aubrey de Vere, Sir Henry Taylor, and Alfred Lord Tennyson, all of whom shared an obsessive interest in reconciling secular and religious issues in art, literature, and poetry. Theology, Christian art, and the poetic consciousness were the subjects of their deepest concern. Dr. Weaver convincingly shows that Mrs. Cameron was not merely a passive mirror reflecting the ideas of others but rather, along with her husband, was among the originators of a new attitude to form and content in art of the mid-Victorian period.

Mrs. Cameron entitled one of her early photographs in the Overstone Album *The Whisper of the Muse* (fol. 75r), and this phrase expresses well the serious concern felt by members of her circle for the intellectual issues involved in reconciling traditional content in art with modern forms of expression. Mrs. Cameron herself echoed the ancient Greek belief in nine muses who inspired creativity in poets, musicians, dancers, and scientists. Long before she thought of using the camera to unite her literary and visual imaginings, Mrs. Cameron was under the spell of Calliope and Polymnia, the muses of heroic and sacred poetry, and wrote her own prayers and, later, poetry, examples of which are also included in this volume.

One of the seven celebrated Pattle sisters, Mrs. Cameron was the third daughter of James and Adeline de l'Etang Pattle. She was born in British India, educated in France, and, as wife to Charles Hay Cameron and mother of six children, became a pillar of Calcutta society. Mrs. Cameron first manifested her creative bent in lengthy literary correspondence with friends and family in England from whom she was separated. In 1874 she translated Gottfried August Bürger's epic poem "Leonora" from its original German. Her husband was a civil servant and jurist by profession, and a philosopher and theologian by

avocation, who pursued his contemplative work without the benefit of a clerical or university post. He encouraged an intellectual atmosphere in the Cameron household which set the stage for Mrs. Cameron to pursue her own interests in art and photography.

In 1848 Charles Cameron retired from active management of the family coffee plantations and returned to England with his wife. In the same year, Anna Jameson's book *The Poetry of Sacred and Legendary Art* was published. Although Mrs. Jameson, who had been born in 1794, lived in England, it is not documented whether these two leading British female intellectuals, one a generation older than the other, ever met. Whether they did or not, Mrs. Cameron and her husband were strongly influenced by Mrs. Jameson's thought.

After their return to England, the Camerons lived successively in Kent and London and on the Isle of Wight before returning to Ceylon in November 1875. During this period Mrs. Cameron met the painter G. F. Watts through her sister, Sarah Prinsep; in Tunbridge Wells the family lived near Sir Henry Taylor, who was a friend; and on the Isle of Wight they resided near Tennyson, who was a constant visitor. All of these men became portrait subjects for Mrs. Cameron, and all are included in the Overstone Album.

A number of individuals have contributed in important ways to this publication and its accompanying exhibitions. Sam Wagstaff taught us an enormous amount about Mrs. Cameron through his collection of her work which the Museum acquired. Daniel Wolf showed great foresight in acquiring the Overstone Album at Sotheby Parke Bernet in 1975 and was the photographs' admiring guardian until they found a permanent home. Ellen Ekedal, Director, Laband Art Gallery, Loyola Marymount University, proposed the idea of expanding the Cameron exhibition planned by the Getty Museum and committed galleries spacious enough to accommodate all of the photographs that Mrs. Cameron presented to Lord Overstone. Gordon Baldwin of the Museum's Department of Photographs coordinated the curatorial and conservation work necessary to prepare the photographs for exhibition and also verified the transcriptions of the documents published here from the Cameron Papers, Archives of the History of Art, The Getty Center for the History of Art and the Humanities. Nicholas Olsberg of the Archives acquired these documents for the Center, thus bringing to Los Angeles an important complementary resource, and his associate, Mitchell Bishop, made them available for study. Robert Aitchison conserved the photographs with the assistance of James Evans, Department of Photographs, and Louise Stover, also in the Photographs department, transcribed the inscriptions and attended to other details of the exhibition and preparation of the manuscript.

Sandra Morgan, Patrick Dooley, Karen Schmidt, and Elizabeth Burke, Department of Publications, and Andrea P. A. Belloli were responsible for seeing the authors' ideas and interpretations into print. Donald Hull and Stephenie Blakemore, Photographic Services, prepared the reproduction photographs of materials in the Museum collection. I wish also to acknowledge the encouragement of Bret Waller, Associate Director for Education and Public Affairs, and the good counsel of Deborah Gribbon, Assistant Director for Curatorial Affairs. Finally, it is to Director John Walsh that we owe the inspiration for acquiring Mrs. Cameron's Overstone Album in the first place. His encouragement and leadership were instrumental in making Mrs. Cameron herself the subject of the Museum's first exhibition and publication devoted to photographs.

<div style="text-align:right">

Weston J. Naef
Curator of Photographs

</div>

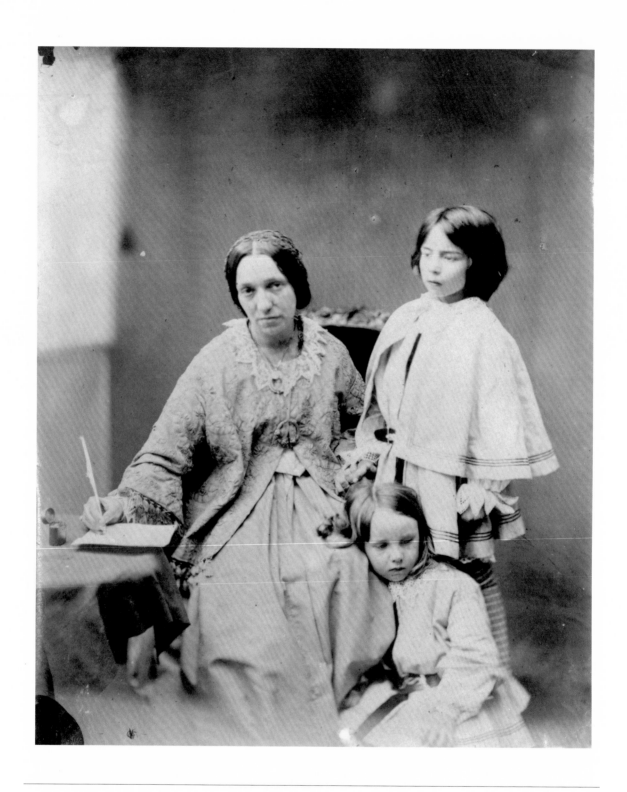

Figure 1. LEWIS CARROLL (CHARLES L. DODGSON) (British, 1832–1898), *Julia Margaret Cameron and Her Children Charles and Henry,* 1859. H: 20.3 cm (8″); W: 16.2 cm (6³⁄₈″). Private collection, London.

A Divine Art of Photography

I

Julia Margaret Cameron (fig. 1) appears to have begun photography in 1863. Within months, in February 1864, she was giving a small album of her work to George Frederick Watts, the painter who was her mentor for the visual arts (pl. 1). In November 1864 she gave another, larger album to Sir John Herschel, the astronomer and photographic chemist whom Mrs. Cameron called her priest and teacher. He had known Mrs. Cameron and her husband, Charles, from the very beginning of their relationship at the Cape of Good Hope.[1] Herschel's album had the benefit of further photographs presented by Mrs. Cameron in September 1867.[2] The album she gave to Lord Overstone (fig. 2), now in the Getty Museum, was presented to him by her on August 5, 1865.

The photographs in the Overstone Album come from the first eighteen months of Mrs. Cameron's work and are not yet of the very highest quality. It is remarkable, though, that her most important subject, the Visitation or Salutation, was present from the beginning. Other Cameron photographs in the collection of the Getty Museum show to what heights she would rise within a couple of years. Her rapid development can only be explained by the fact that she was a wonderfully mature woman with an extraordinary degree of self-education at the time she began—a person with ideas and experience.

Mrs. Cameron did her own photographic work. She proudly inscribed the Overstone Album with the words "*Every* photograph taken from the Life and *printed* as well as taken by Julia Margaret Cameron." We can assume that she also prepared and developed the large glass-plate negatives from which she made her huge contact prints, although she does appear to have had help from a woman servant in later years. Mrs. Cameron was not short of expert advice. Oscar Rejlander helped her, and Jabez Hughes was nearby on the Isle of Wight, where Mrs. Cameron lived during the 1860s, to provide her with materials if necessary. David Wilkie Wynfield introduced her to fancy portraiture, a mode in which the subject exists somewhere between portrait and genre, and Watts deeply influenced her symbolic approach to art. In the end, however, she outstripped them all.

Mrs. Cameron arranged the photographs in the Overstone Album in no special order, but she provided a list of contents (fol. 1r) which groups them, roughly, under three headings: "Portraits," "Madonna Groups," and "Fancy Subjects for Pictorial Effect." There are one or two anomalies in the lists of titles, and a couple of extra images, but the album is marvelously intact. Mrs. Cameron's list of contents is both useful and misleading because her portrait of Tennyson (fol. 2r) should really be among the fancy subjects, since the poet is depicted as an abbot. *The Salutation* (fol. 46r) belongs as much to the Madonna groups as does *Aurora* (fol. 66r). All this proves is that Mrs. Cameron found it helpful to indicate to others what kind of pictures she was making. It will be discovered only later that all her best works can be grouped as fancy subjects for pictorial effect. She was seldom content to leave her subjects solely with their historical identity, without reference to types drawn from the Bible and Shakespeare. On the contrary, she approached most of her subjects with recognition of just such types in mind. Individual representation of a person was not enough. It had to achieve a degree of idealization if it were not to

15

remain at the banal level of a studio portrait. In order to make High Art—art with a moral purpose—Mrs. Cameron had to tap the rich vein of Christian typology.

Because her work was intended to achieve pictorial effect, Mrs. Cameron naturally adapted the photographic technology of her day to that end. Sharp focus was less useful to her than differential, or selective, focus because she sought spiritual meaning rather than particular information from her subjects. Her model was the same as that of Watts: Titian. Cameron's friend Sir Henry Taylor (fols. 4v, 5r, 9r, 25r, 29v) described Titian's method in one of his plays, *St. Clement's Eve* (1862):

> There is a power in beauty which subdues
> All accidents of Nature to itself.
> Aurora comes in clouds, and yet the cloud
> Dims not, but decks her beauty. Furthermore
> Whate'er shall single out a personal self
> Takes with a subtler magic. So of shape;
> Perfect proportion, like unclouded light,
> Is but a faultless model; small defect
> Conjoint with excellence, more moves and wins
> Making the heavenly human.

Rich meaning, "a subtler magic," was Mrs. Cameron's aim, not flawless technique. As Frederick Evans, the British photographer of cathedral interiors and one of her best critics, wrote: "She always meant something, however faultily that something might be worked out."[3]

The man to whom Mrs. Cameron gave her album, Lord Overstone, helped her family financially over a long period of time, giving them more than six thousand pounds. He was not a hereditary peer but the son of a self-made man. His father was a Unitarian minister who gave up the ministry for banking. Samuel Jones Loyd became Baron Overstone of Overstone and Fotheringay in 1850. At the same time that he was elevated to the peerage for his services to banking, he also became a commissioner for the *Crystal Palace Exhibition* of 1851 and a trustee of the National Gallery, London. He acted as a financial guarantor for the exhibition and offered similar guarantees for the *International Exhibition* of 1862. Overstone was vice-chairman of the General Council of the *Manchester Art Treasures Exhibition* of 1857, to which he lent a number of paintings from his own collection. As a member of the House of Lords, he effectively acted as the National Gallery's spokesman. In 1869 he entered wholeheartedly into the defense of the gallery's acquisition of paintings he regarded as authentic works by Rembrandt and Michelangelo; it is hard to imagine Mrs. Cameron not taking a keen interest in the controversy.[4]

Lord Overstone's love of art had its origins in Florence in 1821. As he himself wrote,

> The statue of the Venus de Medici deserves all the praise which can be lavished upon it.
> Statues have always afforded me more pleasure than paintings but I never knew what
> were the powers of this art till I came here. My expectations had been highly raised; but
> I found them far short of the reality. Many things which I have seen in Italy derive their
> reputation, as it seems to me, from the cant of connoisseurship—But this statue is the
> true personification of everything that is elegant and graceful and dignified. It equally
> baffles all attempts to imitate or to describe it.[5]

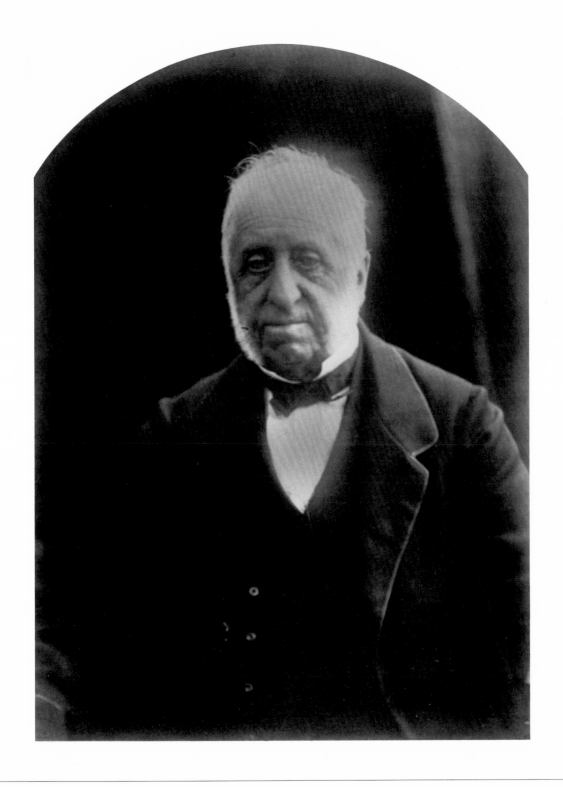

Figure 2. J. M. CAMERON, *Lord Overstone*, 1870. H: 36.5 cm (14 ³⁄₈″); W: 25.6 cm (10 ¹⁄₁₆″). Bath, The Royal Photographic Society.

Overstone's reservations about connoisseurs did not prevent him from appreciating art. He translated Horace's famous lines from *The Art of Poetry* which begin with the words *"Ut pictura poesis"*:

> Pictures, like Poems—This to closer view
> Is best; that, when at a greater distance seen.
> Some love the shade; some seek the brighter light,
> Fearless to face the critic's keenest eye.
> This charms us once; ten times be repeated that,
> Its pow'r retains undimm'd, and pleases still.[6]

Overstone began to collect around 1831. In 1846 he acquired a number of Dutch paintings from Baron Verstolk of the Hague, including works by Rembrandt, Ruisdael, Jan Steen, Wynants, and Van de Velde. A syndicate including Overstone and Thomas Baring, one of the sons of the banking and collecting family of Sir Thomas Baring, had brought a hundred pictures to England and divided them up among themselves. According to Francis Haskell, this was one of the last times this kind of wholesale transaction was undertaken by Englishmen.[7] In 1848 Overstone bought another, smaller group of paintings by Guido Reni, Pieter de Hooch, Adriaen and Isaak van Ostade, and Claude Lorrain. The mixture of Italian, Dutch, and French works exemplifies the open nature of the collector's response to art. This was not the policy of a connoisseur but the reflection of a tremendous interest in all national schools and all periods of art. Overstone shared with Sir William Stirling-Maxwell, whose *Annals of the Artists of Spain* (1847) was illustrated by William Henry Fox Talbot's Reading Establishment, an enthusiasm for Spanish art, particularly the work of Bartolomé Esteban Murillo. The 1840s and 1850s were the great years for collecting and broadening taste in England. Exhibitions of the old masters were the popular prerogative of the British as of no other people in the world. To list some of the artists whose work Overstone lent to the *Manchester Art Treasures Exhibition* is to indicate the range of his collection: Perugino, Rembrandt, Steen, Jacob van Ruisdael, Joshua Reynolds, Claude, Adriaen van Ostade, Adam Pynacker, George Stubbs, Wynants, Lorenzo di Credi, and Murillo. In addition, he owned works by Salvator Rosa, Carlo Dolci, Domenichino, Parmigianino, and Titian. He was, in short, one of the great English collectors.

By 1865, the year in which Mrs. Cameron gave Lord Overstone her album, her husband was in severe financial difficulties. He had retired in 1848 from a career as fourth member of the Council of India and as law commissioner in Ceylon, where it was said in 1850 that he was the largest single land-owner.[8] Fifteen years and several failed coffee crops later, and all hopes of a governor-generalship gone, he must have felt a failure. He was an excellent scholar and devoted to the idea of education in the colonies. In 1829 he had been recommended for the first-ever chair of moral and political philosophy at London University, but was rejected solely on the grounds that he was not in holy orders. His friendship with Lord Overstone, which had begun at Eton College, was secured by the high regard in which Cameron was held by members of the Political Economy Club in London, to which Overstone also belonged.

In September 1866, a year after Mrs. Cameron had presented her album to Lord Overstone, her son-in-law Charles Norman wrote to him on the family's behalf asking for a loan of a thousand pounds: "My father-in-law for the last two months has been utterly penniless, so that his debts are

Plate 1. JULIA MARGARET CAMERON, *G. F. Watts,* 1864. Overstone fol. 38r.

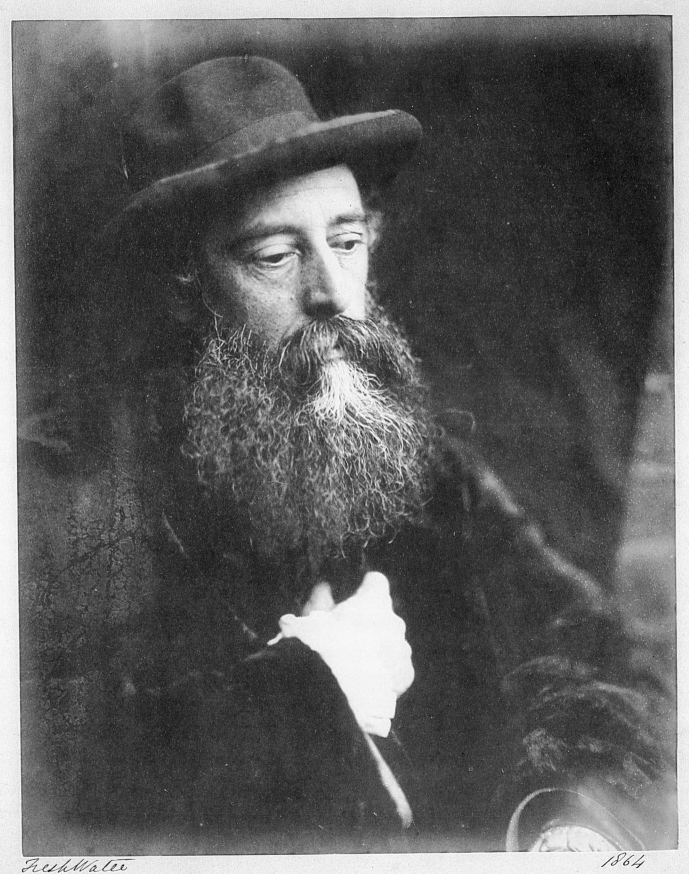

FreshWater 1864

G. F. Watts.

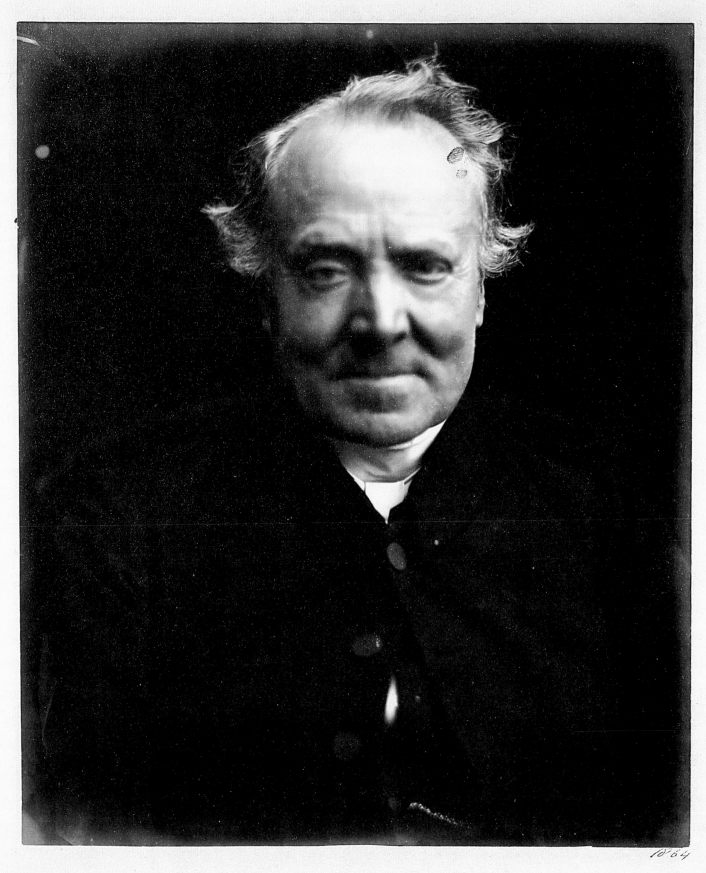

Revd J Isaacson

Rector of Fresh Water.

1864

increased by butcher's Bills, etc."[9] The "etc." may refer to photographic expenses, because in a subsequent letter young Norman wrote, "I have told my mother that it is positively the last time that any assistance of this kind can be given her and that her future happiness or discomfort & misery rests Entirely with herself."[10] Norman's letter does not specify whether Mrs. Cameron was being warned on account of lamb chops and beef or collodion and developer, but it is clear that she was being singled out for blame.

If it was partly photography that was helping to put the Camerons further in debt, then Lord Overstone himself, as art patron and organizer of the *Manchester Art Treasures Exhibition,* had—directly or indirectly—stimulated Mrs. Cameron's creativity. A reviewer described the scene at the exhibition: "The ladies might be seen interrogating, with such lights as they could command, the new world that had opened upon them demanding of ART her secret—attuning their ears to new spiritual harmonies—becoming conscious of a wonderful transfusion into their own souls of the purity and grace of a 'Risposo' or of a 'Visitation'—discerning a new charm in maternal affection, and a new beauty in infantine caresses."[11] But Lord Overstone was also responsible for supporting the greatest pictorial photographer of the nineteenth century, who, as William Michael Rossetti (fols. 5v, 73v) recognized, was re-creating the subject of Christian art with all the considerable lights at her formidable command. G. F. Watts and P. G. Hamerton, the great critic of the graphic arts, agreed with this assessment. "Our English artists tell me that I can go no further in excellence," Mrs. Cameron wrote to Lord Overstone in 1867, "so I suppose I must suppress my ambition & stop—but it is an art full of mystery and beauty & I long to hear your & Harriette's opinion abt. my pictures which you will give me when they have reached you."[12] She wrote this just a year after her husband had been described as penniless.

So the idea of Mrs. Cameron as an amateur photographer belonging to a well-endowed family is utterly fallacious. The financial plight of the family at the very time when she was launching her career in photography suggests that she may indeed have been hoping to do something toward earning money by it. Certainly the view of her as an eccentric lady with nothing better to do than to divert herself by taking photographs must now be revised. Her relations from the very beginning of her career with the print-seller Colnaghi and with the Autotype Company, which later sold carbon prints of her work, suggest a commercial or professional motive.

The family returned to Ceylon in 1875 for the simplest of reasons: they were broke. They were better off living abroad than in England since their expenses were so much lower. This move, which appears to have relieved Mr. Cameron's anxiety and aimlessness, also cut short his wife's photographic career. She had, perhaps, failed to capitalize upon it—to make some money or, rather, to get her money back—but the special combination of cultural factors which had sustained her magnificent contribution to art was also dissolving. These comprised contemporary developments in aesthetics (the serious art historical discovery of Dutch and Italian painting), in the religious arena (the Oxford or Tractarian Movement, which revived the sacraments in the Anglican church), and in the area of technical advances (the new differential-focus lenses of 1866). By the 1880s these factors had spent their force. A fresh combination formed the context for the new work of naturalistic photographers like P. H. Emerson, Mrs. Cameron's first and most important early critic,[13] who were to be concerned with an impressionistic approach to rural genre and landscape photography.

Plate 2. J. M. CAMERON, *Rev. J. Isaacson,* 1864. Overstone fol. 60r.

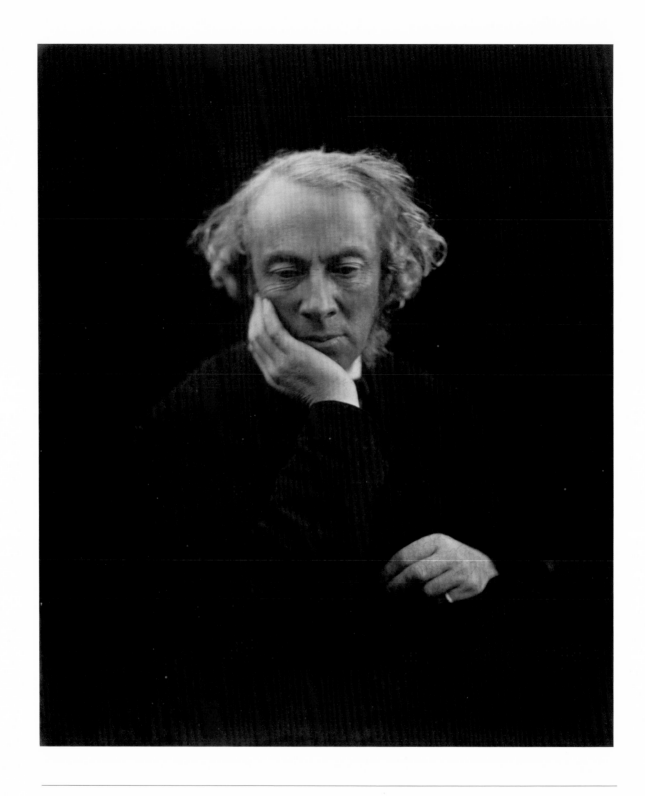

Figure 3. J. M. CAMERON, *Portrait of Aubrey de Vere.* H: 28.6 cm (11 ¼″); W: 22.9 cm (9″). Collection of Mr. and Mrs. Noel Levine, New York.

II

The mid-nineteenth century was the period of the first great popular appreciation of art in Britain. The huge success of the *Manchester Art Treasures Exhibition* and the establishment of the National Gallery and the National Portrait Gallery occurred immediately before Mrs. Cameron began her photographic work. The art historical consciousness of the time was essentially revivalist, and the religious consciousness directed attention toward Christian art.

The early years of the century constituted a great Age of Reform. This period saw the abolition of slavery in the British Empire (1833), the Factory Act to limit the exploitation of child labor, and the New Poor Law (1834). Another consequence of the Age of Reform was the emancipation of Catholics and nonconformists. Catholicism had been held to be idolatrous by earlier generations of English clerics. During the 1800s the prestige of the Church of England was threatened by successive government actions in the direction of greater religious tolerance. In 1833, however, John Keble attacked the Whig reformers as traitors to the Anglican church, thus initiating the so-called Oxford or Tractarian Movement. The *Tracts for the Times,* manifestoes of the Romanizing party in the established Anglican church, became increasingly Catholic in tone. John Henry Newman (later Cardinal Newman) wrote one entitled *"On the Catholicity of the English Church"* and in 1845 finally became a Catholic himself. In the 1860s the poet Sir Henry Taylor (fols. 4v, 5r, 9r, 25r, 29v), a friend of the Camerons, corresponded with Newman. Although the two never met, through their mutual friend the Catholic convert and poet Aubrey de Vere (fig. 3), Taylor had developed a serious interest in Newman's poem *The Dream of Gerontius* (1866) as well as in the *Apologia pro Via Sua* (1864), which was Newman's answer to an attack on him by the clergyman and novelist Charles Kingsley.

Julia Margaret Cameron was well aware of the controversy surrounding the Oxford Movement. Where her own vicar, the Reverend J. Isaacson of Freshwater (pl. 2), stood, whether he was High Church (Anglo-Catholic) or Low Church (almost a dissenting Protestant), is not known. Like her contemporary Anna Jameson, the best Christian iconographer of her day, who avoided the charge of Catholicism by emphasizing the "poetry" rather than the religion of Christian art, Mrs. Cameron approached Italian painting, for example, as an expression of Protestant poetry rather than Romish religion.

The general influence of the Oxford Movement was aesthetic and religious. Poetry was thought by the movement's adherents to be a form of mythology which contained a story with several layers of meaning more or less impossible to disentangle from the story itself. John Keble, well before he became leader of the movement, had shown that he was a Christian apologist who believed in associationism, the philosophy of mind promulgated by David Hartley in *Observations on Man* (1749). James Mill introduced his son, John Stuart Mill, and Charles Cameron to this masterly and influential account of the association of ideas by means of his own *Analysis of the Human Mind* (1829). Cameron's "Essay on the Sublime and Beautiful" (1829) depends upon these influences. Wordsworth and Coleridge also were influenced by Hartley. Coleridge went so far as to name his first son after Hartley, although he restored

the balance later by naming his second son after Bishop Berkeley, the idealist philosopher. Sir Henry Taylor knew both Wordsworth and Coleridge. The point is that Mrs. Cameron, through her husband and her close friend Taylor, was in intimate, if indirect, touch with the theory of the association of ideas. This theory was attractive to a group of philosophical radicals known as the Utilitarians, of which Charles Cameron was one. The Utilitarians believed that if society would rely upon reason rather than law, and if progress could be founded upon education, then social reform was inevitable as well as desirable. They were concerned quite simply with the betterment of society. Association of ideas appealed to them because it rested on sensory stimuli—it was an empirical approach to psychology. Poetry as myth was attractive to John Keble because it reflected and inspired complex associations of ideas of a moral and religious kind in conformity with Christian doctrine. Both Utilitarians and Tractarians accepted the association of ideas as the path to intellectual and moral improvement. The paradox is that Hartley's thought was founded on sensationist or physical theory and yet produced associationist or spiritual effects. He was opposed to secular art, as tending to the lewd and profane. Eminent, or high, art was different, in his view, "an excellent means of awakening and alarming our Affections, and transferring them upon their true Objects."[14] To the Victorian, a hundred years after Hartley, Art was technique, whereas High Art embraced Christian associations. Keble believed that art, as well as literature, could produce moral *and* religious associations:

> Be it addressed to the eyes, ear, or mind only; be it a song of Handel, a painting of Reynolds, or a verse of Shakespeare; if it "transport our minds beyond this ignorant present", if it fill us with consciousness of immortality, or the pride of knowing right from wrong, it is to us, to all intents and purposes, poetry. Nor is it anything uncommon in language to apply the term to these arts. We hear of the poetry of sculpture, the poetry of painting.[15]

The pleasures of association were therefore *poetic* if guided by Christian conscience.

Keble also embraced the possibility of a poetry of everyday objects, events, and persons. This was exactly how photography was relevant for Mrs. Cameron. Photographs are as much indexes of empirical fact as icons of ideal representation. They are taken from nature itself, "from the life," as Mrs. Cameron wrote on many of her prints, as well as being capable of association with the highest Christian ideals. This is the special contribution of photography—never before in the history of art have ontology and epistemology been embodied in a single medium. The historical and the devotional were one to Mrs. Cameron. Thus in her work we find the embodiment of the ideas of Keble and Newman. Hers is a poetry of photography. To quote from Newman's "Poetry" (1829): "With Christians, a poetical view of things is a duty—we are bid to colour all things with the hues of faith, to see a divine meaning in every event and a Superhuman tendency. Even our friends around are invested with unearthly brightness—no longer imperfect men, but beings taken into Divine favour, stamped with His seal, and in training for future happiness."[16] So it was that Mrs. Cameron's treatment of her friends, her servants, her acquaintances, her heroes, and those whom she snatched off the streets like any scout for a model agency had but one aim— to show their divine and superhuman aspect. When Mrs. Cameron inscribed the earliest of her presentation albums to George Frederick Watts, she used the phrase "my mortal yet *divine!* art of photography." She clearly regarded her photographs as theophanies, manifestations of God in terms of living persons— both indexes and icons of the true, the good, and the beautiful. The image for Mrs. Cameron was both mortal and divine, corruptible and sacred. While the Protestant position was essen-

Figure 4. J. M. CAMERON, *Florence/Study of St. John the Baptist,* 1872. H: 34.7 cm (13⅝″);
W: 25.3 cm (10″). Malibu, The J. Paul Getty Museum 84.XM.443.67.

tially to see God manifested down to the human, the Tractarian attitude was to raise the mortal up to the divine.

Mrs. Cameron, then, treated her subjects typologically. A typologist is one who is endlessly preoccupied with the possibilities of relating persons and events from different times and places in history for moral and religious purposes. David Hartley's sense of conscious design in the universe was founded on his recognition that the Bible was constructed on such principles:

> There is an Aptness in the Types and Prophecies to prefigure the Events, greater than can be supposed to result from Chance, or human Foresight. When this is evidently made out from the great Number of the Types and Prophecies, and the Degree of Clearness and Preciseness of each, the shewing afterwards, that these have other Uses and Applications will rather prove the Divine Interposition, than exclude it. All the Works of God, the parts of a human Body, Systems of Minerals, Plants, and Animals, elementary Bodies, Planets, fixed Stars, etc. have various Uses and Subservices, in respect of each other; and, if the Scriptures be the Word of God, Analogy would lead one to expect something corresponding hereto in them.[17]

It is impossible to understand nineteenth-century art criticism—the writings of John Ruskin, for instance—without this concept of typology and analogy. It required not only a knowledge of the Old and New Testaments but, in Mrs. Cameron's case, a knowledge of other "testaments"—classical and British literature. The classical testament was taken for granted by such scholars as her husband; the British testament consisted of writers whom the Tractarians considered religious and moral, such as Milton, Shakespeare, Robert Southey (Taylor's closest literary friend), and Wordsworth. To these Mrs. Cameron added Keats, Taylor himself, and Tennyson.

In typological terms, if Noah was a type of Christ, then King Arthur was a type of Colonel Loyd-Lindsay (pl. 3), Lord Overstone's son-in-law, a Crimean War hero, and founder of the British Red Cross Society.[18] If Rebecca at the well was a type of Mary Madonna, then Mary Magdalene was a type of Tennyson's Maud or Shakespeare's Ophelia (see figs. 11, 12). This analogical or typological way of thinking represented a method of comprehending myth and history from a moral and religious viewpoint. Strictly speaking, the religious point of view did not have to be specifically Christian so long as it was moral. Indeed within the Christian churches there were different ideas of analogy and typology. The Tractarians appear to have preferred the term "analogy" to describe the relation between the natural and moral world, and to have seen such a relation as sacramental. Those of a purely Protestant persuasion seem to have been content to think of typology as biblical, and confined themselves to readings of the Old Testament for its prefigurations or prophecies of Christ. Mrs. Cameron's *Shunamite Woman and her dead Son* and *Infant Samuel* (fols. 48v, 57r) are typological in both senses.

Mrs. Cameron was probably a Tractarian but not a Catholic—what we would call today an Anglo-Catholic. Her portrayals of several of her heroes in Renaissance caps (see fols. 5r, 5v) suggest an interest in the tradition of the early church fathers, which culminated in the Reformation schoolmen. The headdress favored by Holbein for his portraits is of the same kind. On the whole, Protestants, and Angli-

Plate 3. J. M. CAMERON, *Colonel Lloyd Lindsay,* 1865. Overstone fol. 80r.

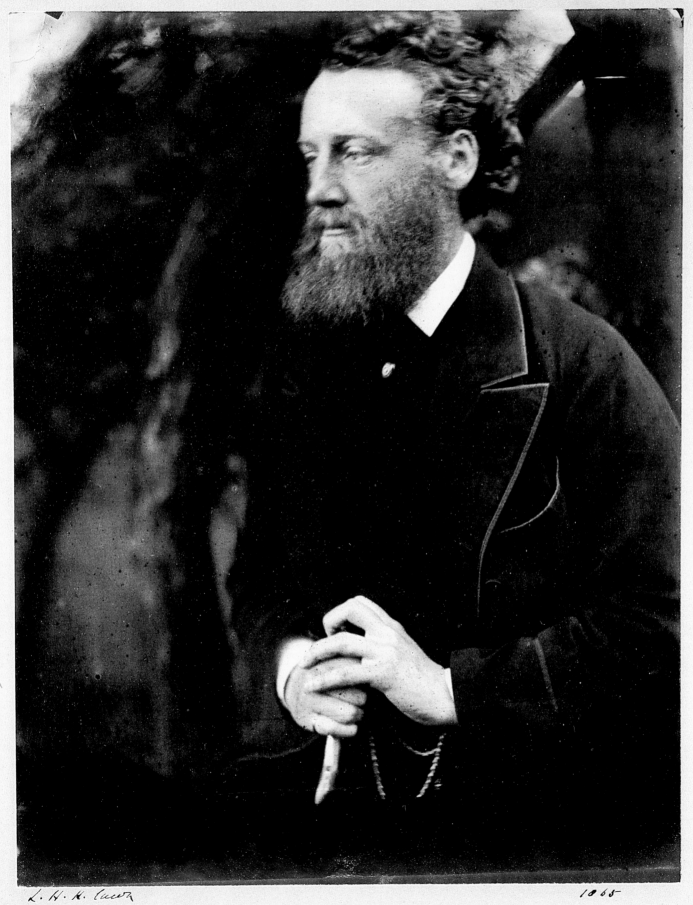

L. H. H. Cameron 1865

Colonel Lloyd Lindsay

Fred Walter 1865

grace thro' Love

cans in particular, have laid great stress on the patristic tradition, especially the writings of Saints Jerome, Ambrose, and Augustine, for doctrinal reasons. Catholics, while very respectful of the patristic tradition, have vested supreme authority in the Church. The Tractarians maintained the middle position, regarding the fathers as empiricists and sacramentalists at the same time. The Tractarians regarded the moral, the religious, and the mystical as based on the poetic, which was related to empirical facts. Flesh and spirit thus were united in their concept of the poetic, so that poetry was the beginning of full theological understanding.

Lord Lindsay, author of *Sketches of Christian Art* (1847), the earliest British work on Christian iconography, thought that the purpose of Christian art was to submit the animal passions, and intellectual pride, to the will of God in the Spirit. Mrs. Cameron entitled a series of her photographs "The Nine Fruits of the Spirit." This phrase comes from the fifth chapter of the Epistle to the Galatians in the New Testament. The context is the wickedness of the flesh in terms of sex and violence ("Adultery, fornication, lasciviousness . . . hatred, wrath, strife"): "But the fruit of the Spirit is love, joy, peace, longsuffering, gentleness, goodness, faith, meekness, temperance: against such there is no law. And they that are Christ's have crucified the flesh with the affections and lusts. If we live in the Spirit, let us also walk in the Spirit. Let us not be desirous of vainglory, provoking one another, envying one another" (5:22–26). Although Mrs. Cameron drew five titles from these verses (see fols. 11r, 19r, 21r, 23r, 24r, 50r, 62r), she left us with several possibilities for meekness and temperance. Meekness could, indeed, be depicted in *Gentleness* (fol. 44r). Mrs. Cameron appears to have given us a second representation of faith in *Trust* (fol. 84r). Most important, however, is the concept behind *Grace thro' Love* (pl. 4), because it suggests that grace may yet be attained through love born of the flesh. This concept represents both the surrender to the flesh by God's will and the caring for another which made Mary divine. Grace is itself a fruit in that you cannot obtain it but only allow it to grow by means of meekness and temperance. Such a consciousness suggests that Mrs. Cameron was always aware of the possibility of slipping from grace, the ultimate and single gift of the Spirit—all the so-called fruits are merely the result of gifts. She once sent her son Eugene

> . . . an illuminated Sermon on the Mount and I hope that whilst he looks at its bright and gold letters he will remember its bright gold precepts, those precepts which are so divine that they *could* only have come from God and they are the most convincing *evidence* of his (God the Son) having lived upon Earth. Mercy—purity of heart—forgiveness for injuries—returning good for evil—simplicity of heart and truthfulness of speech—letting one's yea be yea, and one's nay be nay, without equivocation or argument—love to one's neighbours—*love* to one's *enemies* [—] forgiveness of trespasses—prayers without ostentation—a constant daily dependence upon God's care—a conviction that God who "so clothes the grass and the lilies of the field", will even so provide for us—a withholding of all censure and harsh judgement upon the conduct of others [—] a continual earnest striving to enter in at the straight gate—and a *life* that *agrees* with the prayers that we utter [—] these are all and each of them precepts which are to be found only in the Christian religion and which stamp that Sermon on the

Plate 4. J. M. CAMERON, *Grace thro' Love,* 1865. Overstone fol. 16r.

Figure. 5. Engraving after SIR JOSEPH NOEL PATON (Scottish, 1821–1901), *The Water-Babies*. Reproduced from Charles Kingsley, *The Water-Babies* (London, 1863), frontis.

Figure 6. Engraving after GUIDO RENI (Italian, 1575–1642). Reproduced from Anna Jameson, *Legends of the Madonna represented in the fine Arts,* 2nd edn. (London, 1857).

Mount and every word our holy Savior breathed on Earth with that *stamp of divinity* which *all* can recognize and know that all that is pure and holy and good can *alone* proceed from that God "with whom is every good and perfect gift" and who *alone* is the Fountain of Holiness and purity.[19]

In a letter to Sir Henry Taylor, Mrs. Cameron wrote that men were great "thro' genius" and that women were great "thro' love. Love—that which women are born for."[20] In terms of her Christian beliefs Mrs. Cameron was a typological feminist. She accepted the uniquely female experience of life—the ability to give birth—but defended her sisters within the allegorical or typical framework of the Christian church from the slur of earth goddess. Because of, and in spite of, the female closeness to the rhythms of physical life, women "thro' love" were, in her view, uniquely capable of understanding the emotions attendant upon nativity and crucifixion, death and resurrection. Some of the most tender images in the Overstone Album reflect this consciousness (see fols. 46r, 62v).

Charles Cameron, in his "Essay on the Sublime and Beautiful," was quite willing to acknowledge the power of a purely sexual attraction, a love without benefit of spiritual grace and unmediated by the Christian mystery of spirit: "There are certain qualities of the human figure which naturally excite that very powerful emotion, the desire of sexual intercourse."[21] Mrs. Cameron shows every sign of having agreed. She wrote to her son Hardinge (fol. 7v) to encourage him to marry: "a life that has not known the purer sanctifying influences of love filtering lust is a life that has not yet had developed in it the God as *exalting* and intensifying the human nature and animal side of man and woman which animal side I do not

at all despise. It is the rich soil that bears the golden fruit but if good seed is not sown in that soil it then degenerates into a dung heap does it not?"[22] All of Mrs. Cameron's photographs show an astonishing awareness of "that very peculiar species of beauty, which is found nowhere but in the human form and countenance."[23] There is nothing asexual about her work, yet it never loses the refinement so sorely lacking in the work of such artists as Dante Gabriel Rossetti. But it was only with her images of children that Mrs. Cameron was able to be overtly sexual in her expression. This is the paradox of the Fruits of the Spirit as a sequence—it is so fleshly. A picture like *Spring* (fol. 32r), which bears a relation to *Gentleness* (fol. 44r), somewhat surprisingly shows the sexual parts of the Jesus figure to be female. Androgyny was an aspect of Cameron's feminism at the theological level. This is not an isolated instance. Her studies of Saint John the Baptist at later ages employ a female model (fig. 4), and her Angel at the Tomb is invariably female (see figs. 15, 17). A certain theological androgyny offered the possibility to photograph nude children, something that might otherwise have been taboo in the Victorian period. Sexuality is incarnated here as a mystery without negative connotations.

The case of Charles Kingsley's *Water-Babies* (1863) is most interesting in this respect. Kingsley, a sensualist within marriage, could enjoy the idea of sex only in the context of water—or a cold shower! *The Water-Babies* is a book about a necessarily very dirty little boy, a chimney-sweep, who finds himself suddenly in the amniotic world of Mrs. Doasyouwouldbedoneby, whose name was suggested by Galatians 5:13–15: "For, brethren, ye have been called unto liberty; only use not liberty for an occasion to the flesh, but by love serve one another. For all the law is fulfilled in one word, even in this; Thou shalt love thy neighbour as thyself. But if ye bite and devour one another, take heed that ye be not consumed one of another." Mrs. D. is an all-embracing mother figure among the babes. That the image of the ideal mother appealed to Mrs. Cameron is shown in a letter to her daughter: "I have also sent you a very pretty fan with little pictures of dear Babies on their mother[']s knee and it will remind you of the time when your Mama was blessed by having you on her knee and your sweet arms round her throat and your dear head leaning on her fond bosom."[24] Mrs. Cameron's title for her photograph *The bereaved Babes* is a joke on the subject because *The Mother moved!* and therefore "lost" her head (fol. 67r). The passage in *The Water-Babies* which must have appealed most to Mrs. Cameron was the one that the Scottish painter Sir Joseph Noel Paton illustrated (fig. 5):

> She was the most nice, soft, fat, smooth, pussy, cuddly, delicious creature who ever nursed a baby; and she understood babies thoroughly, for she had plenty of her own, whole rows and regiments of them, and has to this day. And all her delight was, whenever she had a moment to spare, to play with babies. And therefore when the children saw her, they naturally all caught hold of her, and pulled her till she sat down on a stone, and climbed into her lap, and clung round her neck, and caught hold of her hands; and then they all put their thumbs in their mouths, and began cuddling and purring like so many kittens.[25]

It is the two children on the right of Paton's composition who deserve our attention here—the two who do not suck their thumbs but who embrace in the manner of Cameron's *Double Star* (pl. 5). As type-characters they are Jesus and the Child Baptist. To the right of them is a fish-serpent, a seaweed-tree, and a starfish-crucifix. It is John who bears witness with a kiss. *The Double Star* proposes him as the last person in the Old Testament and Jesus as the first in the New, now brought into perfect typological register. They are not twins but the doubles of each other. This type-form is to be found in paint-

ings of the Holy Family by Fra Bartolommeo (London, National Gallery) and Bernardino Luini (Madrid, Museo del Prado) in which Saint John and Jesus embrace. Lord Overstone had at least two paintings of this subject in his collection, one by Francia and another attributed to Cesare de Sesto, which Mrs. Cameron had probably seen.

The idea of the children as innocent lovers carries over into another subject, *The Infant Bridal* (fol. 18r), the title of which was drawn from a poem by Aubrey de Vere. The theme of child marriage is also significant in *Paul and Virginia* (fol. 4r), an image related to the book of the same name by Jacques-Henri Bernardin de Saint-Pierre, which was published in an illustrated edition by Cürmer in 1838. The taste for these subjects is justified in Tractarian terms by Keble's poem from *Lyra Innocentium* (1846), a kind of *Christian Year* for teachers and nurses. In the poem, called "Children Like Parents," the nurse, or mother, leans over her sleeping child and discerns among its features both a family likeness and a resemblance to the holiest of all children:

> For of her Saints the Sacred Home
> Is never quite bereft;
> Each a bright shadow in the gloom,
> A glorious type hath left.
>
> So in earth's saintly multitude
> Discern we Saints above:—
> In these, the Fountain Orb of Good,
> Pure light and endless Love

This last line seems to have been a source for *Light and Love* (fol. 11v), which is a version of the *Madre Pia,* in which the Virgin worships the Godhead in her son.

The "Madonna Groups," as Mrs. Cameron called them in the Overstone Album, suggest a not wholly systematic attempt to treat various aspects of the Virgin. Anna Jameson gives an account of them in *The Poetry of Sacred and Legendary Art.* She distinguishes between the devotional and the historical appeal of sacred art:

> Devotional pictures are those which portray the objects of our veneration with reference only to their sacred character, whether standing singly or in company with others. They place before us no action or event, real or supposed. They are neither portrait nor history. A group of sacred personages where no action is represented, is called in Italian a *sacra conversazione;* the word *conversazione,* which signifies a society in which there is communion, being here, as it appears to me, used with peculiar propriety. All subjects, then, which exhibit to us sacred personages alone or in groups, simply in the character of superior beings, must be considered as *devotionally* treated.[26]

The paradox about Mrs. Cameron's position is that photography's ontological status makes all her work historical, no matter what she may have done to give it epistemological status or pictorial effect. *The first born* (fol. 12r), to eyes insensitive to dress, suggests a contemporaneous Victorian picture. The degree to which the mother leans over her child, should, however, alert us to the fact that this is a *Madre Pia,* such as Mrs. Jameson illustrated from Guido Reni (fig. 6). At about the same time that she made *The first born,* Mrs. Cameron experimented with a more explicitly devotional treatment of the

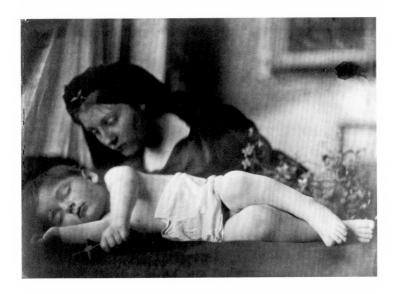

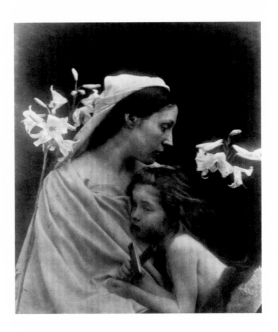

Figure 7. J. M. CAMERON, *The Shadow of the Cross/From Life August 1865,* 1865. Signed: l. r., *Julia Margaret Cameron.* H: 27 cm (10 ⅝″); W: 36.5 cm (14 ⅜″). London, Victoria and Albert Museum.

Figure 8. J. M. CAMERON, *Study—Madonna,* 1870. H: 32.8 cm (12 ¹⁵⁄₁₆″); W: 28 cm (11″). Bath, The Royal Photographic Society.

subject, usually entitling these prints *My Grandchild,* omitting to say, however, that the woman in the picture was not the child's mother but a housemaid. The child on its own in these images might have been the subject of a traditional baby picture by a commercial photographer of the 1920s, but the attitude of the "mother" clearly identifies the composition as a *Madre Pia.* However, on some prints Mrs. Cameron added the words "My Grand-Child Eugene's boy Archie, born Barbados, 23 May 1863, aged 2 years & three months." On another version, for G. F. Watts, she wrote, "My grandchild and my chef d'oeuvre." Historically, the picture is of Archie; devotionally, it is of the Redeemer. In another version she was more explicit; *The Shadow of the Cross* (fig. 7) includes not only the flowers of purity but a little wooden cross clutched in the child's hand. Whereas in Italian Renaissance painting the child often lies upon a cross the length of his whole body, Mrs. Cameron was more subtle: the legs are crossed in evocation of the single-pinned feet of the Crucifixion. This is an excellent response to Mrs. Jameson's requirement that "We need the pathetic contrast between innocence and His predestined fate to convey the religious feeling."[27]

The Overstone Album contains other images that are not so successfully realized, perhaps, as *The Shadow of the Cross.* The experiments leading to the latter suggest the use of more than one glass-plate negative to produce a combination print, as does *Hosanna* (fol. 62v). The three women in some prints of this image are divided by a plate line from the child. This is a new subject—that of the three Marys at the foot of the cross (pl. 6). And in Mrs. Cameron's *Hosanna* the cry of adoration is muted in an expression of grief. The title is ironic because the women who attend Christ's nativity are also imaginatively assisting at his deposition. *The Vision of Infant Samuel* (fol. 68r) is an Old Testament pre-

figuration or type of Christ. Mrs. Cameron had a special affection for Samuel. She gave her daughter a "very pretty wee figure of the Infant Samuel which I send to you knowing that you love as I do this beautiful and holy and pious Child."[28] In the Overstone image Samuel is unconscious of the meaning of his vision, which Mrs. Cameron scratched and brushed on the glass negative. The same kind of pathos carries over to two other Nativity pictures, *Prayer and Praise* (pl. 7) and *A Christmas Carol* (fol. 56v). Despite the titles, the feeling evoked in the first is closer to a *pietà* than a nativity scene (see the man standing in for Andrew or John), and in the second, Joseph is less the father of our Lord than Joseph of Arimathea. But in all these photographs Christ's destiny is foreshadowed across time and space. Mrs. Cameron's method is both analogical and synchronic—whether three or thirty-three, Christ is crucified through all the years.

The fruit of the spirit is an outgrowth of the gift of the spirit in Mrs. Cameron's work. The fruit of *Grace thro' Love* (pl. 4) is the gift of charity, the most important of the theological virtues (*charis* means grace). The gift enables the fruit to ripen. *Faith* and *Hope* (fols. 24r, 62r) are gifts and fruits at the same time. In 1845 Mrs. Cameron sent her daughter "a little ornament which you can wear of three pretty seals and on these three seals are engraven—an anchor—a cross and I *think* a star but I forget what was on the third seal. When I saw [it] it struck me that the three devices would be good emblems of faith [—] hope—and charity—which are the three great principles of our Christian Religion."[29] The Italian titles for the Madonna groups in the Overstone Album are supplemented by English versions. They depict the Virgin as watching, resting hopefully, waiting, sorrowing, rejoicing, keeping her secret, and so on. Perhaps waiting and watching embody prudence, and resting and rejoicing, hope. But it seems that Mrs. Cameron was not too exact in this, and that fruit and gift were interchangeable for her. What is certain is that she regarded expression on the human face as potentially divine. *Grace thro' Love* (pl. 4) and *La Madonna Adolorata* (fol. 20r) need to be closely compared. In the first the Virgin is lost in a trance of both love and death. Her cheek brushes Christ's forehead in the same way as in the great *pietà* by Rogier van der Weyden (Madrid, Museo del Prado), although the spirit of Mrs. Cameron's picture has not the hardness of Flemish painting but the softness of Italian or Spanish.[30] But behind the soft treatment lies a harsh reality, which is recognized in *La Madonna Adolorata*. The child looks scared. The mother is abstracted and helpless in her sorrowful knowledge; she is wretched beyond hope. The child is horribly conscious of his fate for once. *Goodness* (fol. 21r), *décolletage* and bare legs notwithstanding, is more successful in celebrating Mary's virtue than the girl-child's sulkiness. Mrs. Cameron's title covers her against impropriety, and, to quote Mrs. Jameson's words about another picture, "The theme, however inadequately treated as regards its religious significance, [is] sanctified in itself beyond the reach of a profane thought."[31]

The Madonna groups with two children include John the Baptist. As already remarked, he can be female, as in *Spring* (fol. 32r). His attribute is the cross, which bears witness to Christ's significance for the world, as in *Long-suffering* (pl. 8). In *Love* (fol. 23r) the drapery between the two children is arranged to form a triangle that connects Mary, Jesus, and John at each of its points. This three-way connection, with connotations of the Holy Spirit, relates not only the children to each other but also the two mothers. Roger Fenton, the greatest landscape photographer among Mrs. Cameron's contempo-

Plate 5. J. M. CAMERON, *The Double Star*, 1864. Overstone fol. 58r.

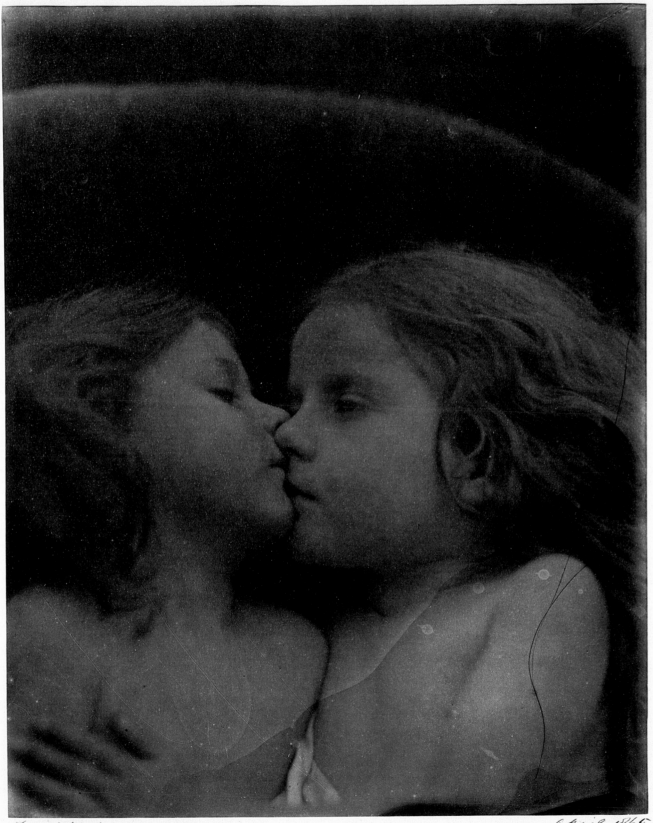

Fresh Water

April 1864

The Double Star

54

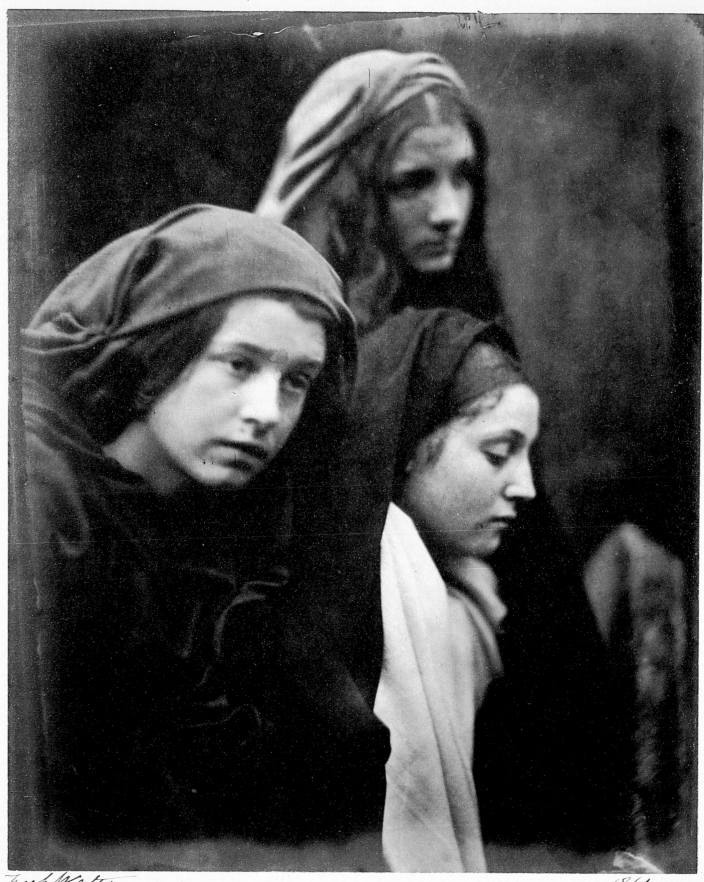

Fred Watts 1864

The three Marys.

raries, chose to contribute to *The Photographic Album for the Year 1857* a reproduction of a relief that showed Mary receiving Elizabeth's child, John the Baptist, at his birth.[32] Mrs. Cameron's beautiful picture of Mary nursing John, with the goatskin and cross that are his attributes (fig. 8), confirms her devotion to the theme of solidarity between the two women: Mary so honors Elizabeth's child. Of course, John also acts here as the angel of the Annunciation; Madonna lilies suggest that Christ is not yet born.

The bond between the two women, mothers of *The Double Star* (pl. 5), is affirmed in several pictures in the Overstone Album. Mrs. Cameron was preparing from the beginning of her career for her greatest single picture, *The Kiss of Peace* (fig. 9), made in 1869. There is an evocation of the theme in *Aurora* (fol. 66r), but *The Salutation* (fol. 46r) is a clearer indication of the theme of a relation between two women: "And it came to pass, that, when Elizabeth heard the salutation of Mary, the babe leaped in her womb; and Elizabeth was filled with the Holy Ghost: And she spake out with a loud voice; and said, Blessed art thou among women, and blessed is the fruit of thy womb. And whence is this to me that the mother of my Lord should come to me?" (Luke 1:41–43). Mary gives the greeting, but Elizabeth, it seems to me, bestows the kiss of blessing. This makes Mary Hillier, Mrs. Cameron's maid, who usually played Mary in her compositions, play Elizabeth, conflating the character-type of Mary with that of Elizabeth. They, too, are a double star. The sacredness of childhood embodied in the holy children is matched by the sacredness of womanhood in their holy mothers. An experiment with this theme is the cropped, alternative version of *The five Wise Virgins* (fol. 30v), called *A Group,* which includes only two figures (fol. 69r). Like Lady Elcho (fol. 69v), these women become sibyls, bringing light to the Gentiles, even as John was not that light himself but was sent to bear witness to it (John 1:8). The two women at the Salutation or Visitation also *incarnate* that light—they bear it in their wombs.

The parable of the Wise and Foolish Virgins normally typifies the Last Judgment. John Everett Millais illustrated it,[33] and Mrs. Jameson made an engraving of it as the frontispiece of the second volume of her *Sacred and Legendary Art.* But the Tractarian doctrine of reserve, of holding back from the unworthy what they do not deserve to know, was used by Mrs. Cameron in the cropped *five Wise Virgins.* One of the most beautiful versions of the theme of the Visitation is also carefully concealed under the title *"Flos and Iolande"* (pl. 9). The two girls this time are characters in Sir Henry Taylor's play *St. Clement's Eve,* which Mrs. Cameron read aloud (lunch and tea provided) to a group of Pre-Raphaelite painter-friends when it was published. As type-forms the girls in *"Flos and Iolande"* resemble the compositions described earlier, except that their white apparel makes them appear exemplary brides of Christ. In the play, however, Flos is betrayed by her lover and filled with hatred. A reverend father comments, "How swift/The transformation whereby carnal love/Is changed to carnal hate!" Iolande falls in love with a nobleman whom she discovers to be married. She breaks off her relationship with him, but is left feeling sullied. The women's fates are quite disproportionate to their indiscretions, but in Taylor's scheme of things they feel and act as fallen women. So it is that *"Flos and Iolande"* reserves to itself the character-type of the fallen woman as well as the type-form of the Visitation. These are two women filled with sorrow and not blessed with children. The type they represent is the one to which the least amount of attention has been paid in any study of Mrs. Cameron's work, and the one most crucial to the understanding of it: the Magdalene figure.

Plate 6. J. M. CAMERON, *The three Marys,* 1864. Overstone fol. 84v.

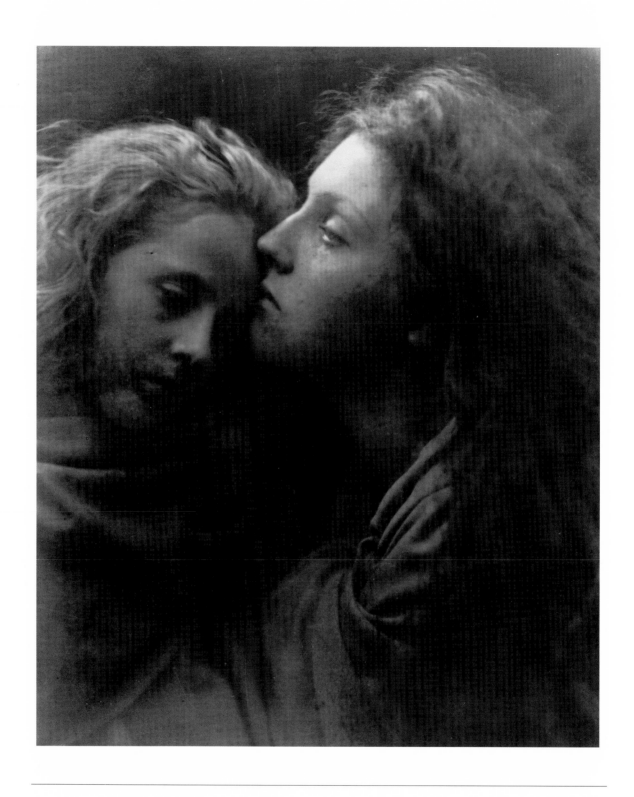

Figure 9. J. M. CAMERON, *The Kiss of Peace,* 1869. H: 34.3 cm (13 ½″); W: 27.7 cm (10 ¹⁵⁄₁₆″). Bath, The Royal Photographic Society.

III

The combination of the historical with the devotional which was essential to Mrs. Cameron's work resulted not just from the status of photography as an art form based on reality but also from the doctrine of reserve of the Tractarians. Charles Cameron wrote, "Men not only suppose they see what they really do not see, but also frequently suppose they do not see that which they really do."[34] Mr. Cameron was writing from a psychological rather than a religious point of view, but John Keble would have doubtless agreed with him. Mrs. Cameron felt such reverence and respect for her subjects that in her very greatest pictures, *The Kiss of Peace* and *The Dream* (figs. 9, 10), she did not declare their nature but relied on the fact that those prepared would recognize them.

The earliest Magdalene figure in Mrs. Cameron's work may well be a family friend, Magdalene Brookfield (fol. 33v). She not only bears the name but in one of the pictures (fol. 79v) is shown in a garden like Tennyson's Maud (fig. 11). Tennyson gave Mrs. Cameron an inscribed copy of *Maud and Other Poems* (1855) and she made several studies of this disturbed figure. Maud is a type of the Magdalene, first in a long line of such types which included Shakespeare's Ophelia, Goethe's Gretchen, Beatrice Cenci, and Tennyson's Elaine from *Idylls of the King* (1859) (figs. 12–14).

Mary Magdalene, it is generally agreed, was one of the Marys at the foot of the cross and at the Entombment. But the Mary Mrs. Cameron has presented is the one to whom Christ appeared at the Resurrection. Mrs. Jameson made something of the fact that it was a woman to whom he first declared himself at that time: "Early theology has not overlooked the coincidence which places woman—'the last at the Cross, the first at the Tomb'—in a position here morally reversed to that she assumed in the Garden of Eden."[35] Mrs. Jameson endorsed the view that of all whom Christ had left on earth, Mary Magdalene was the one most desolate and in need of consolation, but it might be added that the woman was not a saint but a sinner—by reputation a harlot. The fallen woman is thus at the center of the greatest mystery of Christianity. When she mistakes Christ for the gardener, he turns to her with one word, "Mary." John Ruskin thought this must have been the sweetest sound in a believer's ear in the whole history of Christendom.[36] It is certainly a moment of high drama in Saint John's gospel.

In Saint Matthew's version of the story, however, there was a prior event that Mary Magdalene also witnessed: "And, behold, there was a great earthquake: for the angel of the Lord descended from heaven, and came and rolled back the stone from the door, and sat upon it. His countenance was like lightning, and his raiment white as snow" (28:2–3). On one print of *The Angel at the Tomb* (fig. 15), Mrs. Cameron wrote "God's glory smote her on the face (a *coruscation* of spiritual & unearthly light is playing over the head in mystic lightning flash of glory)." Indeed this is the case, but the angel has changed sex, and furthermore, Mary Magdalene's major attribute, her hair, is dazzlingly presented. At this earthquake in her soul her elaborate tresses are tousled and tangled as never before in the history of art. Mrs. Cameron has conflated the angel with—another "angel." Mary's long hair was required in the Bible so that she could dry Christ's feet and was legendarily God-given to conceal her nakedness as a fallen

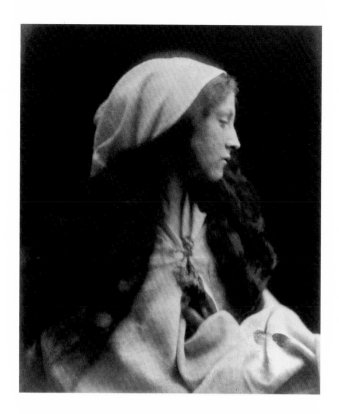

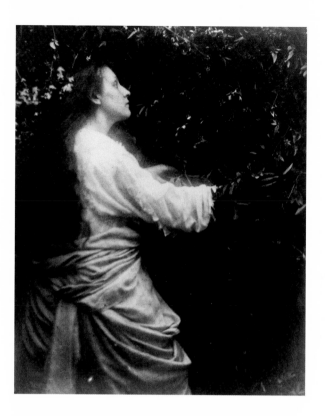

Figure 10. J. M. CAMERON, *The Dream/ "Methought I saw my late espoused saint,"* 1869. H: 30.3 cm (11 ¹⁵⁄₁₆"); W: 24.4 cm (9 ⅝"). Bath, The Royal Photographic Society.

Figure 11. J. M. CAMERON, *A Study for "Maud,"* circa 1875. H: 37.5 cm (14 ¾"); W: 27.9 cm (11"). Bath, The Royal Photographic Society.

Eve. It was metaphorically appropriated in the Victorian period to suggest a certain glorious looseness of morals. Child-bride that she was, Ellen Terry (fols. 41r, 42r), although married to Mrs. Cameron's friend G. F. Watts, was not allowed to let her hair loose upon her shoulders in company. Mrs. Cameron, along with Charles Dickens, felt that long hair made women beautiful, even it if did make them metaphorically loose. George du Maurier satirized the Pre-Raphaelites' excessive fascination with long tresses. But Mrs. Doasyouwouldbedoneby (fig. 5) had them, as did the beautiful child who acted as the Madonna figure in *Days at Freshwater* (fig. 16). In another Magdalene picture, called *The Angel at the Sepulchre* (fig. 17), which marks the moment when Mary was left to grieve alone, the loose hair on her drooping head is visible beneath the dark drapery. The Madonna lily suggests that she is already purified by her love of Christ, whereas in *The Angel at the Tomb* (fig. 15) she is struck full in the face by a lightning love. Typologically, the Magdalene is related to the daughter of Zion in search of her spouse: "The watchmen that go about the city found me: to whom I said, Saw ye him whom my soul loveth? It was but a little that I passed from them, but I found him that my soul loveth: I held him, and would not let him go" (The Song of Solomon 3:3–4). In the garden Christ said, "Do not hold me." Traditionally it was thought that this was because Mary Magdalene was a harlot. However, Christ went on to say, "for I am not yet

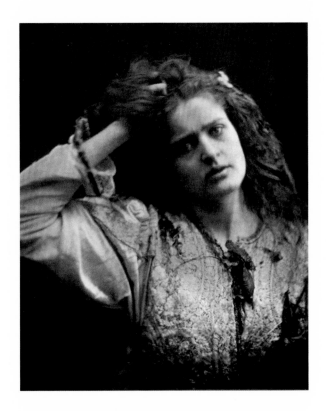

Figure 12. J. M. CAMERON, *Woman with Hand to Head,* circa 1875. Colnaghi blind stamp. H: 34.6 cm (13⅞"); W: 29.9 cm (11⅞"). Malibu, The J. Paul Getty Museum 84.XM.349.15.

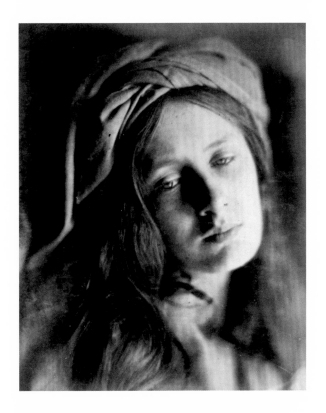

Figure 13. J. M. CAMERON, *Beatrice/From Life Registered/Photograph copy right,* 1866. Signed: l. r., *Julia Margaret Cameron Fresh Water 1866.* Colnaghi blind stamp. H: 33.7 cm (13¼"); W: 26.2 cm (10¹⁵⁄₁₆"). Malibu, The J. Paul Getty Museum 84.XM.443.36.

ascended to the Father" (John 20:17). The mystery was incomplete. Mrs. Cameron's two pictures of the angel have given us two aspects of the Magdalene's experience, as mourner and lover of Christ.

The story of Lancelot and Elaine in Tennyson's *Idylls of the King* is one in which a virginal Elaine adores an adulterous Lancelot. Like Iolande, she is a victim of adultery rather than a perpetrator of it. Yet Lancelot's sin is somehow visited upon Elaine to the point where she is cast in a pseudo-Magdalene role. Guinevere and Vivien are the true Magdalenes, as Enid is a Madonna. Elaine sings her "Song of Love and Death":

> I fain would follow love, if that could be;
> I needs must follow death, who calls for me;
> Call and I follow, I follow; let me die.

She is a kind of Lady of Shalott.

Mrs. Cameron herself translated "Leonora," the story of another pseudo-Magdalene type,

from the German of Gottfried August Bürger and had it illustrated with Daniel Maclise's steel engravings (fig. 18). Sir John Herschel, Dante Gabriel Rossetti, and William Whewell, the Cambridge scientist, had also translated this poem, which was popular because of the influence of German Romanticism in England in that period. The spectral bridegroom of "Leonora," a tale of Death and the Maiden, is paralleled in Christina Rossetti's *Goblin Market* (1862), a book of parables of spiritual wickedness which Mrs. Cameron gave to Tennyson. Leonora's lover has gone to the wars, and she despairs of his faithful return. It is her despair that is her sin. Her mother tries to console her and urges her to take the sacrament:

> Be calm my child, forget thy woe,
> And think of God and heaven;
> God, thy Redeemer, hath to thee
> Himself for bridegroom given.
>
> Oh! mother, mother, what is heaven?
> Oh! mother, what is hell?
> To be with William, that's my heaven
> Without him, that's my hell.
>
> Come death! come death! I loathe my life;
> All hope is in death's gloom
> My William's gone, what's left on earth?
> Would I were in his tomb.[37]

Death comes by, indeed, in the guise of William, and carries Leonora off to a nuptial bed in the grave. The moral of the story is not to imprecate against God's will. There is no suggestion of any loss of integrity or virginal wholeness in the character. It is the lack of penitence which condemns her. Today, outside the church, penitence is widely regarded as irrelevant to the modern condition. Self-assertion, rebellion, and independence of all others have become secular ideals. But Rossetti and Herschel, like Mrs. Cameron, obviously did not share this notion when they translated Bürger's poem.

Tennyson's *May Queen* (1833) is a less moralistic version of the story. The girl has been elected Queen of the May and is identified with the Virgin. She has rejected her lover's suit on that account. But by New Year's Eve things are different:

> Tonight I saw the sun set: he set and left behind
> The good old year, the dear old time, and all my peace of mind;
> And the New Year's coming up, mother, but I shall never see
> The blossom on the blackthorn, the leaf upon the tree.

In Mrs. Cameron's picture of the same title (fig. 19), the Magdalene and the Madonna are emblematically combined. The nosegay is the English version of the garland of roses which is emblematic of the Virgin and often surrounds an image of her in Renaissance painting. In *The May Queen* she clasps it to her

Plate 7. J. M. CAMERON, *Prayer and Praise,* 1865. Overstone fol. 72r.

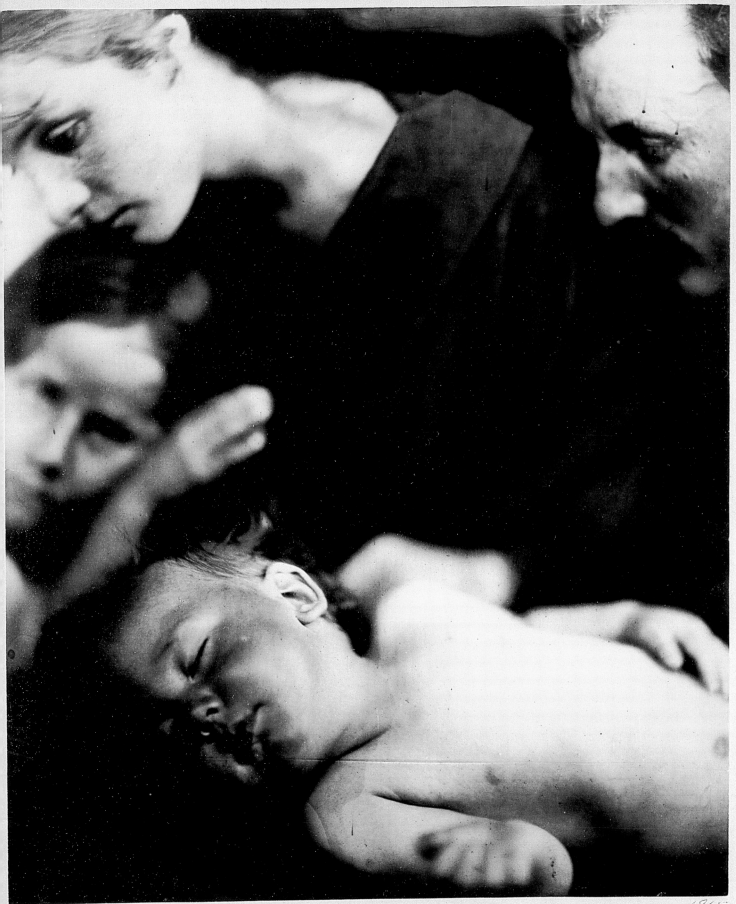

Fresh Water 1865

Prayer and Praise

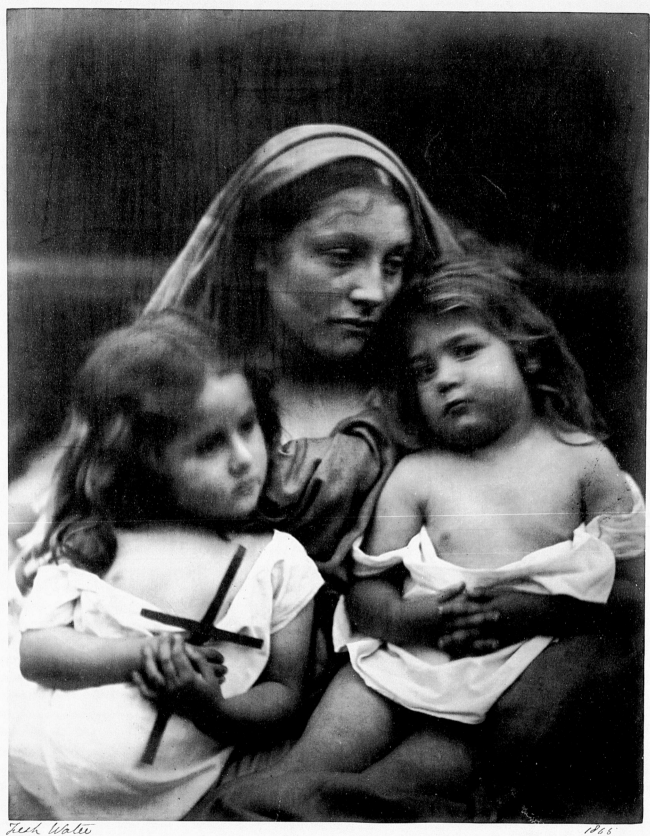

Fresh Water 1866

Long-suffering

"Fruits of the Spirit."

heart. But her loose hair, despite the nimbus of her straw hat, betrays her as a type of the Magdalene. The angle of her head confirms this view, especially in relation to Mrs. Cameron's study of Ophelia (fig. 12), where the hand in the hair, the look in the eyes, and the half-open mouth express the distracted nature of the girl wronged by Hamlet. As Mrs. Jameson wrote of Ophelia, "When thrown alone amid harsh and adverse destinies, and amid the trammels and corruption of society without energy to resist, or will to act, or strength to endure, the end must needs be desolation."[38] In the cases of the May Queen, of Ophelia, and of Flos and Iolande, there is no firm suggestion that they have lost their virginity. The point is that they feel, rightly or wrongly, that they have lost their integrity. Ophelia kills herself; Leonora pays the price of impenitence; Iolande is penitent, but dies a violent death. Only the May Queen dies peacefully, in penitence.

Mrs. Cameron's *Dream* (fig. 10) is one of her finest pictures. She made more than one attempt to get the balance between the Madonna elements and those of the Magdalene exactly right in pictorial effect. The eyes are no more cast down than those of *The Angel at the Tomb* (fig. 15), and the hair is displayed in profusion, but the lilies of the valley, merely suggested (not sharply focused) at the breast, and the natural halation of the headdress announce the subject, to those with eyes and hearts trained to see, as the penitent Magdalene. No wonder G. F. Watts endorsed it as "Quite Divine."[39] But Mrs. Cameron did not entitle the picture to give its subject away easily. In calling it *The Dream,* she was alluding to Milton's sonnet on his dead wife, in which she comes to him, clad in white apparel, in a vision of sleep. The keynote of his poem is relevant to the idea of the Magdalene-Madonna dichotomy. He addresses his wife as "my late espouséd saint":

> Mine, as whom wash'd from spot of child-bed taint
> Purification in the old law did save;
> And such, as yet once more I trust to have
> Full sight of her in Heaven without restraint.

The rite of purification known in the Anglican church as "The Churching of Women" implies carnal uncleanness after childbirth. Childbirth is a work of the flesh rather than a gift of the spirit. But Mrs. Cameron's unsentimental and uncringing presentation of the figure of Milton's wife, a type of Magdalene, confirms that, far from accepting the ruthless dichotomy between divine and human love, she acknowledged the interactive nature of God-given and sexual love. Mrs. Cameron's relations with her husband, her own six children, and the children whom she adopted suggest that she was a fully mature human being whose physical and spiritual life was completely integrated. Those who charge her with eccentricity deserve our indignation. It is a cheap calumny against a completely *centered* woman. She celebrated the sexual-spiritual conflation of the Magdalene-as-Madonna just as she affirmed the androgynous in John the Baptist. Wholeness and holiness were one for her.

The greatest picture that Mrs. Cameron ever made was *The Kiss of Peace* (fig. 9), in which her polytypical imagination was most fully reserved and yet most fully expressed. P. H. Emerson called it "A picture instinct with delicate observation, sweetness and refinement. One of the noblest works ever produced by photography."[40] He knew it was great even if he did not say why. The woman on

Plate 8. J. M. CAMERON, *Long-suffering,* 1865. Overstone fol. 50r.

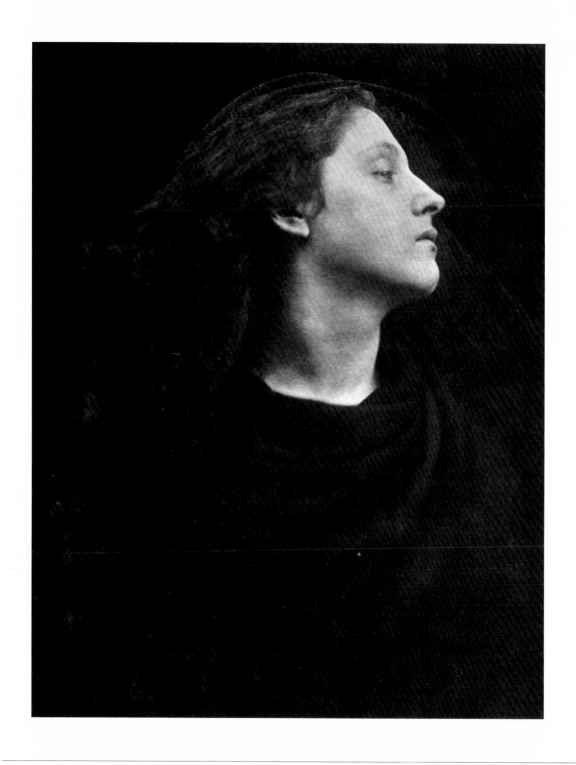

Figure 14. J. M. CAMERON, *Call, I Follow, I Follow. Let Me Die,* circa 1867. H: 38.9 cm (14 ⅛″); W: 27.1 cm (10 ¹¹/₁₆″). Malibu, The J. Paul Getty Museum 84.XM.349.13.

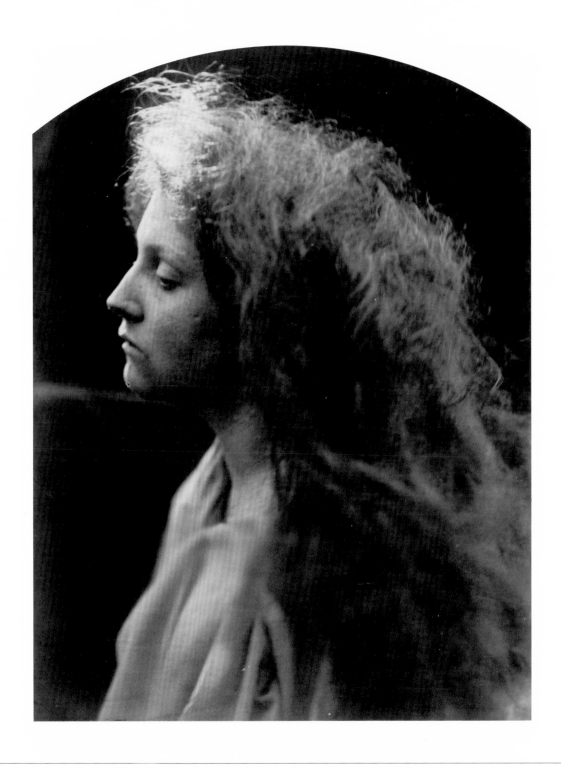

Figure 15. J. M. CAMERON, *The Angel at the Tomb/From Life Registered Photograph Copyright,* 1869.
Signed: l. r., *Julia Margaret Cameron Fresh Water 1869.* H: 35.3 cm (13⅞″); W: 25.7 cm (10⅛″).
Malibu, The J. Paul Getty Museum 84.XM.443.6.

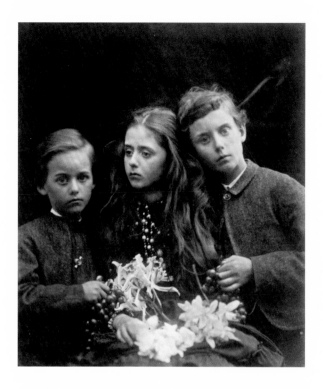

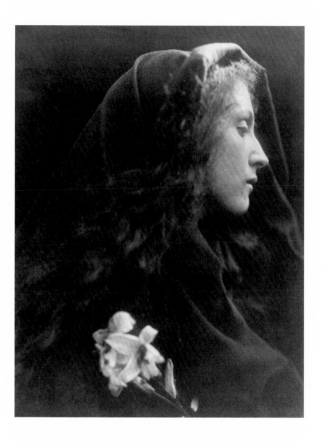

Figure 16. J. M. CAMERON, *Days at Freshwater,* 1870. H: 34 cm (13⅜″); W: 28.4 cm (11 3/16″). Los Angeles, Collection Leonard and Marjorie Vernon.

Figure 17. J. M. CAMERON, *The Angel at the Sepulchre,* 1869. H: 35.3 cm (13⅞″); W: 25.6 cm (10⅛″). London, Victoria and Albert Museum.

the right is the figure in *The Angel at the Tomb* (fig. 15), but with her head elevated, she is in the love-death ecstasy of the figure in *Call, I Follow, I Follow* (fig. 14). This is the type-form of Flos and Iolande, who considered themselves as fallen; this is the Magdalene aspect of *The Kiss of Peace.* But there is a Madonna aspect, too. For an appreciation of this we need to recall the Madonna figure in *Grace thro' Love* (pl. 4). That Mrs. Cameron's maid, Mary Hillier, played the role of both the Madonna and the Magdalene is an especially integrative factor.

But who, then, is the girl on the left in *The Kiss of Peace*? She is the same beautiful child in a picture that disguises its types under the title *Days at Freshwater* (fig. 16). In this image she transcends her historical role as Lady Florence Anson (with her two brothers) to take up the devotional role as a girl with both the long hair of the Magdalene and the lilies of the Madonna between types of John and Jesus bearing grapes. The two scouts sent out by Moses to reconnoiter the land of Canaan did so "in the time of the first ripe grapes.... And they came to the brook Eshcol, and cut down from thence a branch with one cluster of grapes, and they bare it between two upon a staff" (Numbers 13:20–23). This story provided painters with attributes for the Christ Child such as pomegranates, figs, and, of course, grapes. Thus it is that the two boys in *Days at Freshwater* and two women in another of Mrs. Cameron's

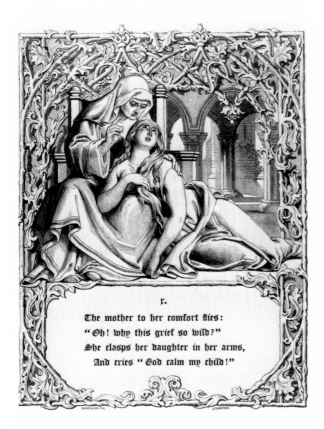

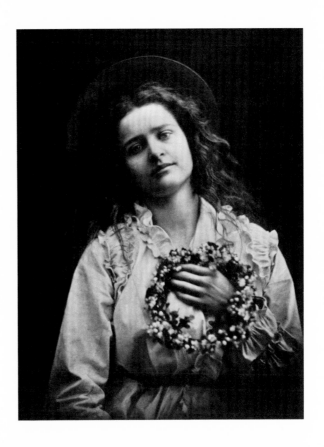

Figure 18. JOHN THOMPSON (British, 1785–1866), steel engraving after DANIEL MACLISE (Irish, 1806–1870). Reproduced from Gottfried August Bürger, *Leonora,* trans. J. M. Cameron (London, 1847).

Figure 19. J. M. CAMERON, *The May Queen,* registered 1875. Brown carbon print. H: 33.3 cm (13⅛″); W: 25.4 cm (10″). Bath, The Royal Photographic Society.

pictures, *Sisters,*[41] carry grapes. Pressed into wine they become the blood of Christ at the Eucharist. In Renaissance painting John is associated with the Hermes-Bacchus myth and sometimes bears grapes. This use of a Greek myth from the classical testament did not surprise Charles Kingsley: "Somehow or other, both the historic and prophetic writings of the Bible, or narratives from them, had reached Greece as well as other distant lands. The Greeks had, at a very early period, embodied in their myths even the personal characters as shown in those writings. Let us without referring to their Zeus in a particular manner, find in the Hermes or Mercury of the Greeks the identity with Moses."[42] He went on to equate Moses and Hermes as messengers. As a good typologist he might have added John the Baptist.

The Kiss of Peace comprises in one figure not just Mary Magdalene but the Angel at the Tomb, John the Baptist, and his mother, Elizabeth. In the other figure it comprises both a Madonna of the Long Hair and her son, Jesus. The image is an extraordinary encapsulation, but perfectly consistent with early Christian iconography of the Visitation, in which the two children are depicted as embryos in their mothers' wombs. The mothers are as inside their children as their children are inside them. The double star is now quadrupled—and more. Mrs. Cameron's *Story of the Heavens* (fig. 20) refers to the

Figure 20. J. M. CAMERON, *A Story of the Heavens/From Life,* 1865. Signed: l. r., *Julia Margaret Cameron.* H: 13.8 cm (5⁷⁄₁₆″); W: 18.5 cm (7⁵⁄₁₆″). Malibu, The J. Paul Getty Museum 84.XM.443.13.

Gemini, or Twins, who in one tradition represent the Dioscuri, Castor and Pollux, sons of Zeus who were devoted to one another. All these strands of myth, and types of analogy, are incarnated in *The Kiss of Peace.* Finally, the *osculum pacis* is the salutation between communicants at the Mass. It was also given and received at baptism, at the absolution of penitents, and at betrothal. To the Anglo-Catholic the Eucharist *is* Christianity. This image is Mrs. Cameron's supreme statement of faith.

Plate 9. J. M. CAMERON, *"Flos and Iolande,"* 1864. Overstone fol. 53r.

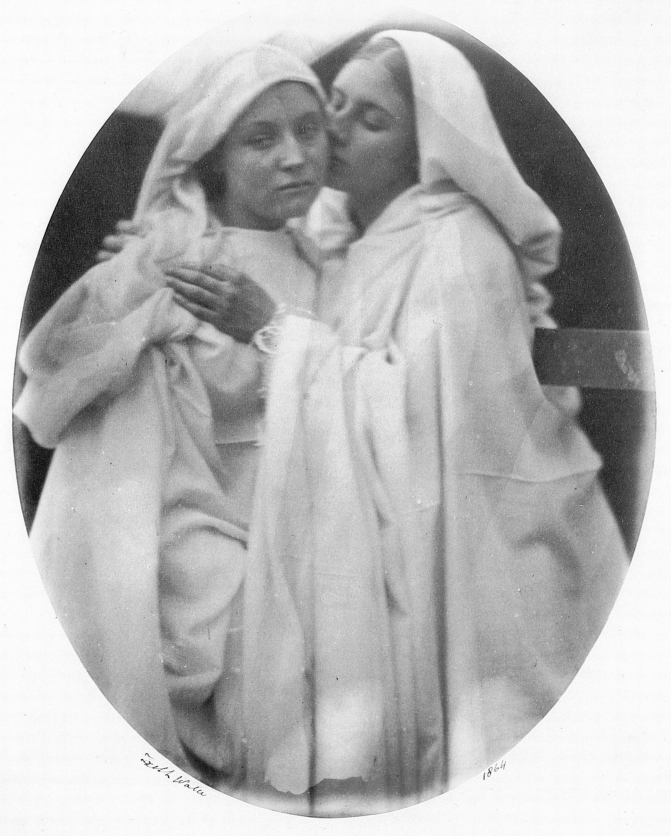

"Flos and Iolande"

from St Clements Eve

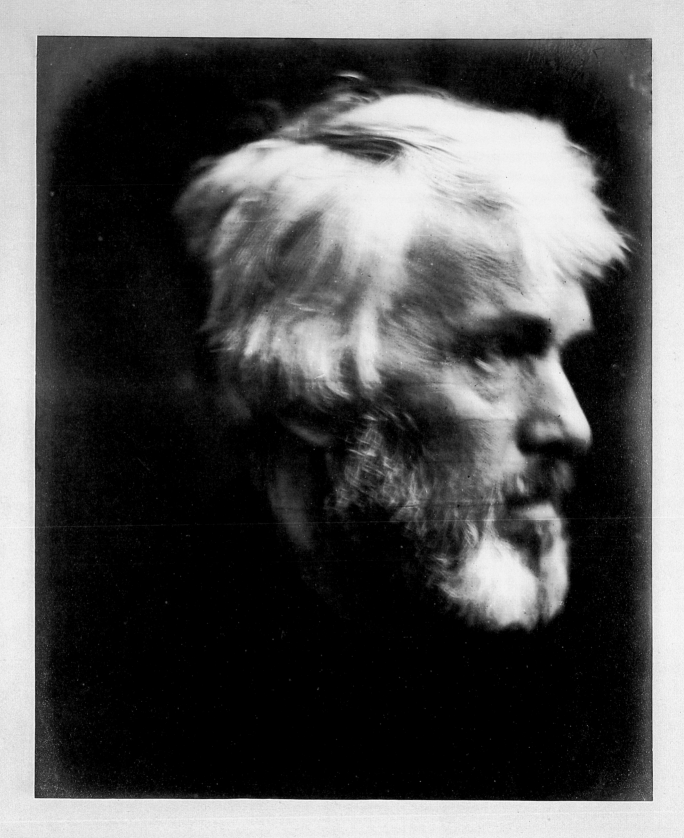

T. Carlyle

IV

The iconographer Anna Jameson thought that Christian art was a form of hero-worship. She was referring to the series of lectures which Thomas Carlyle (pl. 10) published as *On Heroes, and Hero-Worship, and the Heroic in History* (1841). The caps worn in certain of Mrs. Cameron's pictures of men may, it has been suggested above, indicate her patristic interests. To the early church fathers it was essential that God should have become man in order to redeem man from his human nature. What kind of man Christ was has been the subject of endless speculation by christologists, including J. R. Seeley, successor to Charles Kingsley as professor of modern history at Cambridge University. Mrs. Cameron discussed Seeley's *Ecce Homo* (1865) with Sir John Herschel, who wrote about it, "There is a great deal . . . that I certainly would not have written—These chapters about the Law of Resentment and about man being a law unto himself—taken together, admit of being pushed to very ugly conclusions."[43] In general, the image of the historical Christ which Seeley projected was meek and mild, the stereotype in the Victorian period. But in the two chapters referred to by Herschel, "The Law of Resentment" and "The Christian a Law Unto Himself," a sterner image is created. The notion that instead of prescribing laws for society, Christ gave to every member of it the power of naming laws for himself would surely not have appealed to Charles Cameron, the jurist who had spent the best part of his early life engaged in composing social and legal codes. But lawmakers, in Seeley's view, based their rules on reason, whereas Christ called for compassion—the passion to do to others as you would have others do to you and to love the human quality in every person, base as well as noble. Such a doctrine, liberal and lawless at the same time, would indeed have seemed very dangerous to the conservative Herschel. The law of resentment is the anger of Christ directed against the reasoners, the Pharisees. This revolutionary fury guaranteed his murder at their hands. Seeley identified the modern equivalents of these legalists: "It was a class not less influential and important than might be produced in England by fusing the bar, the clergy, and the universities and the literary class into one vast intellectual order." What characterized them was their capacity for professionalizing the original insights of those who came before them; "What they dread is the necessity of originating, the fatigue of really being alive." They were worse than harlots because they were essentially incorrigible monopolists: "[Christ] says, 'You have taken away the key of knowledge; you enter not in yourselves, and those that were entering in you hinder.'" This brood of vipers engenders the bitterest resentment because it betrays the ideal of wisdom: "It would be better that the Jews should have no teachers of wisdom at all, than that they should give them folly under the name of wisdom. Better that in the routine of a laborious

Plate 10. J. M. CAMERON, *Thomas Carlyle,* 1867. H: 30 cm (11 ¹³⁄₁₆″); W: 24.1 cm (10 ½″). Malibu, The J. Paul Getty Museum 84.XM.443.17.

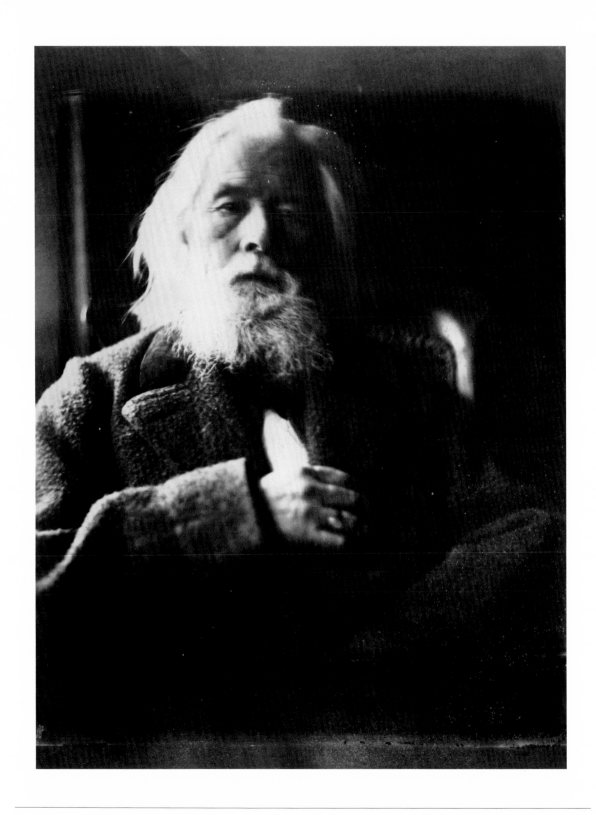

Figure 21. J. M. CAMERON, *Charles Hay Cameron*, 1864. Overstone fol. 60v.

Figure 22. J. THOMPSON, wood engraving after
WILLIAM HOLMAN HUNT (English, 1827–1910),
The Good Haroun Alraschid. Reproduced from
Alfred Lord Tennyson, *Poems* (London and New
York, 1857).

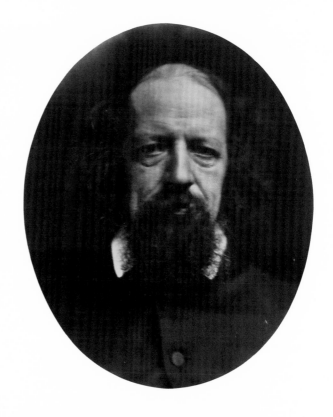

Figure 23. J. M. CAMERON, *[Tennyson],* circa
1867. H: 28.5 cm (11 ³/₁₆″); W: 22.7 cm (8 ¹⁵/₁₆″).
Malibu, The J. Paul Getty Museum 84.XM.443.58.

life they should hear of wisdom as a thing more costly than pearls beyond their reach, than that it
should be brought within their reach and they should discover it to be paste."[44]

Mrs. Cameron has been maligned as a lion-hunter when she was, more correctly, a true
hero-worshipper. Hero worship can, indeed, be pushed to very ugly conclusions, as we continue
to see in the twentieth century. Carlyle's doctrine of hero-worship was derived from philosopher-
kings like Plato, the Plutarchian law-givers, and the Hebraic Messiah. Mrs. Cameron's characteriza-
tion of man's gift for genius against woman's gift for love forms part of this doctrine. With genius
went the concept of force, as expressed in a poem she wrote entitled "On a Portrait":

> Genius and love have each fulfilled their part,
> And both unite with force and equal grace
> Whilst all that we love best in classic art
> Is stamped forever on the immortal face.[45]

Christ was compact of force *and* grace, but Carlyle's hero was never meek and mild. He possessed a
compelling knowledge and force, and he compelled others to accept them both. Abbot Samson, the
twelfth-century hero of Carlyle's *Past and Present* (1843), may be the source of the portrait of Alfred

Figure 24. J. M. CAMERON, *Henry Taylor/A Portrait,* 1865. H: 27.5 cm (10 ⅞″); W: 21.8 cm (8 ½″).
London, National Portrait Gallery.

Tennyson with a book (fol. 2r). This picture has become known as "The Dirty Monk," possibly because Tennyson saw at once how Mrs. Cameron had treated him, and made a joke of it. But the whole point for Mrs. Cameron was to meet Mrs. Jameson's challenge: "What can be more unpromising as subjects for the artist, than the religious orders of the Middle Ages, where the first thing demanded has been the absence of beauty and the absence of colour? . . . these seem most uncongenial materials out of which to evolve the poetic, the graceful and the elevating!"[46]

Pharisaical priggishness and pompousness are quite absent from Mrs. Cameron's spiritual treatment of the real, so her subjects almost never wear dress hats and dress coats but rather caps and jackets, which actually draw less attention to their physical bodies. These garments are artificial in that they were put on especially for sittings, but the resulting images are more natural in effect than any studio portrait of the day. Beards work in the same way. The more shaven her men, the more conventional they appear. As P. G. Hamerton wrote in 1879:

> It was not by any means accidental that the beard movement should have originated with artists, who, however artificial their pursuit may be in itself, are brought more into contact with real nature, and are more observant of its beauties, than any other class of persons. On the other hand, shaving had generally formed part of the ideal aimed at by disciplined professions, such as those of the soldier, the lawyer, and the priest.[47]

Mr. Cameron's beard in one photograph (fig. 21) tells us plainly where he stood on this matter. The photographs of William Holman Hunt (fols. 8r, 56r) are fancy pictures in that they refer to him as the painter of the Holy Land, as the illustrator of Tennyson's "Recollections of the Arabian Nights" (1830), and as Haroun Alraschid, the subject of that poem (fig. 22). William Michael Rossetti (fols. 5v, 73v), one of those who supported Mrs. Cameron's efforts as a photographer, is treated as a man of letters. In *The Whisper of the Muse* (fol. 75r), George Frederick Watts is presented not as himself but as an inspired prophet. Mrs. Cameron may have had in mind Rembrandt's *Saint Matthew the Evangelist* (Paris, Musée du Louvre), in which the child muse whispers in the saint's ear as he begins to write his gospel. Interestingly, Mrs. Cameron switched Watts' occupation from painter to musician by including the violin. She was responsive, it seems, to the analogy between literature and music (as opposed to literature and painting) then being advanced by members of the Aesthetic Movement. This change is reflected in her poem "On a Portrait":

> Oh, mystery of Beauty! who can tell
> >Thy mighty influence? who can best descry
> How secret, swift, and subtle is the spell
> >Wherein the music of thy voice doth lie?

Mrs. Cameron regarded Colonel Loyd-Lindsay (pl. 3), winner of the Victoria Cross in the Crimean War, as the type of King Arthur. Certainly, he has something of the appearance found in pictures Mrs. Cameron made later to illustrate Tennyson's *Idylls of the King*. This is the hero as warrior, less obviously manly than Lord Elcho the soldier (fol. 70r), but more spiritual because more modest. The manliness is on his brow rather than in his sword-arm.

Sir Benjamin Jowett (fol. 55v), an Oxford theologian, knew that Tennyson, from his earliest

interest in the Arthurian legend, had been concerned to treat it in terms of religion.[48] Mrs. Cameron's personal involvement in the later evolution of Tennyson's poem is shown by two facts. On June 28, 1859, he read to her and Mrs. Tennyson his "Sir Pelleas and Ettare" in preparation for a new beginning on his *Idylls*. On August 16, 1859, Mrs. Cameron gave the poet a set of three beautiful volumes of Malory's *Morte d'Arthur* edited by Thomas Wright.[49] Mrs. Cameron was perfectly aware that Tennyson himself was only too mortal. She recounted how when he was tired and bored he would insist on taking her for a walk because *she* looked tired and in need of fresh air.[50] The historical Tennyson was by no means simple and good and true, as she knew. However, she saw the devotional Tennyson, the poet as hero, as nothing less than King Arthur, the English Messiah. Blasphemous though it is to say so, Tennyson was, for Mrs. Cameron and others, the very type of Christ. Her finest picture of the poet is one made in 1867 (fig. 23), in which his eyes are veiled, intense, and wayward at the same time. He is vulnerable and forceful, looking with his left eye through us, and with his right past us. In such a look there is pain, resentment, and mercy, but not much forgiveness. In *Prospero* (fol. 25r), Sir Henry Taylor is suspicious, ruthless, and unmerciful. He recognized it himself when he wrote on one print, "Caezar Borgia!" As Jeremiah (fig. 24), however, he was more equable than the figure painted by Michelangelo in the Sistine Chapel in Rome, to which Mrs. Cameron was alluding.[51]

We cannot avoid the fact that Mrs. Cameron's men are, on the whole, authoritarian figures, compulsive and compelling in the manner of Carlyle's heroes. But reverence for heroism can lead to cruel exploitation—Mrs. Cameron's father-figures are very dangerous to their daughters. This is a strong theme in her work: Prospero and Miranda, Friar Lawrence and Juliet, King Ahasuerus and Esther, Jephthah and his daughter, King Lear and Cordelia. What did Cordelia ever do but refuse—in public—to tell her father she loved him? *Beatrice* (fig. 13) is Beatrice Cenci, the ultimate type of the girl abused by an older man—her father. In treating such subjects, Mrs. Cameron consciously displayed the dark side of male authority. With the insight of genius as well as affection, she recognized dark forces in the greatest of men. In her fusion of the tragic with the prophetic, the sinful with the pure, and the actual with the typical, she assured herself an immortality in the history of photography as certain as her hope in heaven.

NOTES

1. "The Cape has formed an influential point in both our histories" (Sir John Herschel to Mrs. Cameron, June 16, 1839 [Los Angeles, The Getty Center for the History of Art and the Humanities, Archives of the History of Art, Cameron Papers, Box 850858, hereafter GCHAH, Cameron Papers]).

2. See Colin Ford, *The Cameron Collection (The Sir John Herschel Album)* (London and New York, 1975).

3. F. H. Evans, "Exhibition of Photographs of Julia Margaret Cameron," *Amateur Photographer* 40 (July 21, 1904), p. 44.

4. I am indebted to the editor of Lord Overstone's correspondence, D. P. O'Brien, for this and other information. The scope of the *Manchester Art Treasures Exhibition* was enormous; it included 5,711 objects, of which 1,812 were paintings and 597 were photographs.

5. *The Correspondence of Lord Overstone,* ed. D. P. O'Brien (Cambridge, 1971), vol. 1, p. 181.

6. *A Catalogue of Pictures Forming the Collection of Lord and Lady Wantage* (London, 1905), n.p. (opp. Preface).

7. F. Haskell, *Rediscoveries in Art* (Oxford, 1980), p. 128.

8. Charles Hay Cameron to Mrs. Cameron, November 8, 1850 (GCHAH, Cameron Papers).

9. Charles Norman to Lord Overstone, September 2, 1866. This and subsequent letters quoted from Norman and Mrs. Cameron to Lord Overstone are from the Overstone Papers, University of London Library (Ms. 804), by kind permission.

10. Charles Norman to Lord Overstone, September 28, 1866.

11. Nectarine Sunnyside [!], "The Manchester Art Treasures Exhibition," *Photographic Art Journal* 1 (1858), p. 6. Whether Mrs. Cameron went to Manchester is not known, but she would have had a view of all the pictures from *Photographs of the "Gems of the Art Treasures Exhibition"* (Manchester, 1857). These photographs were taken by Caldesi and Montecchi. A copy of this publication exists in the Getty Museum's Department of Photographs.

12. Mrs. Cameron to Lord Overstone, November 5, 1867.

13. P. H. Emerson, "Mrs. Julia Margaret Cameron," *Sun Artists* 5 (1890), pp. 33–42.

14. D. Hartley, *Observations on Man, His Frame, His Duty, His Expectations* (London, 1749), pt. 2, p. 254.

15. J. Keble, *Occasional Papers and Reviews* (Oxford, 1877), pp. 152–153.

16. Cited in G. B. Tennyson, *Victorian Devotional Poetry* (Cambridge, Mass., and London, 1981), p. 41. I am greatly indebted to G. B. Tennyson's beautiful book.

17. Hartley, *Observations on Man,* pt. 2, p. 160.

18. [Harriet S. Wantage], *Lord Wantage V. C., K. C. B.: A Memoir* (London, 1907), p. 136. In her inscription on fol. 80r of the Overstone Album, Mrs. Cameron omitted the hyphen and incorrectly spelled "Loyd" with a double "l." She also misspelled "Shunammite" on fol. 48v.

19. Mrs. Cameron to Julia Cameron, April 7, 1845 (GCHAH, Cameron Papers).

20. Mrs. Cameron to Sir Henry Taylor, July 1, 1876 (Bodleian Library, Oxford).

21. C. H. Cameron, *Two Essays* (London, 1835), p. 33.

22. Mrs. Cameron to Hardinge Cameron, April 3, 1873 (GCHAH, Cameron Papers).

23. C. H. Cameron, *Two Essays,* p. 33.

24. Mrs. Cameron to Julia Cameron, April 7, 1845 (GCHAH, Cameron Papers).

25. C. Kingsley, *The Water-Babies* (London, 1863), pp. 213–214. A painting by Sir Joshua Reynolds depicting the heads of five angelic children was loaned to the *Manchester Art Treasures Exhibition* by Lord Overstone and bears comparison with Mrs. Cameron's photographs of children. See *Photographs of the "Gems."*

26. A. Jameson, *The Poetry of Sacred and Legendary Art,* 9th edn. (London, 1848), vol. 2, p. 11.

27. A. Jameson, *The History of Our Lord,* compiled by E. Eastlake (London, 1864), vol. 2, p. 381.

28. Mrs. Cameron to Julia Cameron, April 7, 1845 (GCHAH, Cameron Papers).

29. Ibid.

30. Of the two Murillos loaned to the *Manchester Art Treasures Exhibition* by Lord Overstone, that depicting the Virgin and Child is noteworthy for the softness of treatment. See *Photographs of the "Gems."*

31. A. Jameson, *Legends of the Madonna* (London, 1852), p. 115.

32. *The Photographic Album for the Year 1857, being contributions from the members of the Photographic Club* (London, 1857).

33. See *The Parables of Our Lord and Saviour Jesus Christ* (London, 1863).

34. C. H. Cameron, *Two Essays,* p. 58.

35. Jameson, *The History of Our Lord,* p. 273.

36. *Ruskin's Letters from Venice 1851–1852,* ed. J. L. Bradley (New Haven, 1955), p. 246.

37. "Leonora" is reprinted in full in M. Weaver, *Julia Margaret Cameron, 1815–1879* (London and Boston, 1984), pp. 146–151.

38. A. Jameson, *Characteristics of Women* (London, 1832), vol. 1, p. 254.

39. Watts' inscription was reproduced on the mounts used by Colnaghi for Mrs. Cameron's photographs.

40. Emerson, "Mrs. Julia Margaret Cameron," p. 41.

41. See Weaver, *Julia Margaret Cameron,* pl. 2.2.

42. [Charles Kingsley], "The Poetry of Sacred and Legendary Art," *Blackwood's Magazine* 65 (February 1849), pp. 177–178.

43. Letter printed in Ford, *The Cameron Collection,* p. 142.

44. [J. R. Seeley], *Ecce Homo* (London, 1865), pp. 260–261.

45. For the whole poem, see Weaver, *Julia Margaret Cameron,* p. 158.

46. A. Jameson, *Legends of the Monastic Orders* (London, 1850), p. xviii.

47. P. G. Hamerton, *Portfolio Papers* (London, 1889), pp. 189–190.

48. Hallam Tennyson, *Alfred Lord Tennyson: A Memoir,* (New York, 1897), vol. 2, p. 464.

49. Hallam Tennyson, *Materials for a Life of Alfred Tennyson* (n.p., n.d.), vol. 2, p. 220; *Tennyson in Lincoln,* compiled by Nancie Campbell (Lincoln, 1971), vol. 1, p. 28.

50. Mrs. Cameron to Sir Henry Taylor, July 5, 1875 (Bodleian Library, Oxford).

51. See Weaver, *Julia Margaret Cameron,* pls. 3.2, 3.5.

Documents

The following prayer, letters, and poem are drawn from a group of Cameron documents that were acquired recently by the Archives of the History of Art, The Getty Center for the History of Art and the Humanities, Los Angeles. They had been purchased earlier at the estate sale of Hardinge Hay Cameron, Mrs. Cameron's third son, and subsequently preserved by Neville Hickman of Birmingham, England. The documents include eight letters from Mrs. Cameron to Hardinge, seven from Sir John Herschel to Mrs. Cameron or her husband, manuscript accounts of her life in Ceylon, and poems and letters sent to Mrs. Cameron or Hardinge by Sir Henry Taylor. There is also a larger group of letters and other papers, such as trust documents, of Mr. Cameron; Henry Herschel Hay Cameron, another Cameron son; and especially of Hardinge and his family.

The prayer reproduced here, written in 1838 when Mrs. Cameron was expecting her first child, Julia, is preserved on a single sheet folded to make four leaves. The long letter, dated October 19, 1871, was written to Hardinge, who was then living in Ceylon. The lists of expenditures and outstanding bills that precedes this letter, "Account of Lord O[verstone]" and "Account of Julia Duckworth" (Mrs. Cameron's niece), are bound together with the letter to Hardinge. Mrs. Cameron's poem "Farewell of the Body to the Soul" is preserved in an envelope dated March 19 and postmarked Ceylon, March 1876. Finally, the apparently incomplete letter dated November 20, 1876, has no salutation nor did Mrs. Cameron sign it.

Mrs. Cameron was a prolific letter-writer, and, judging from contemporary accounts and the documents themselves, she wrote in haste, although she rarely crossed out a word. Her orthography, while occasionally careless, was orthodox, but she disdained the use of the paragraph. Since Mrs. Cameron did not break the texts of her prayer and two letters in any way, they have been broken here to reflect pagination in the originals, thereby facilitating their reading. The folded sheets she used, perhaps drawn from small notebooks, provided Mrs. Cameron with narrow pages; these in combination with her expansive hand sometimes resulted in as few as three words to a line.

Mrs. Cameron's individualistic style bears little relation to conventional models and is best described as discursive, although this is not to say that she did not expend many pages on a given subject before she raced to the next. She employed both the very short sentence and the very long one, compounded by numerous ampersands. A few commas and other marks (and some missing words) have been inserted in brackets here to clarify meaning in some of her longer formulations. Altogether, the effect is warm, compassionate, and eager to the point of breathlessness. The range of her subjects is astonishingly broad and reflects the entire spectrum of high Victorian social and political concerns along with a full complement of domestic matters. In all, these documents serve to confirm and amplify the impression made by Mrs. Cameron's photographs; they reveal a strong-minded, imaginative, erudite, and energetic woman.

Prayer written when I quickened with my first Child
July 8, 1838.

Most merciful Lord God who in Thy loving kindness
dost bestow upon me blessings which I deserve not &
in Thy mercy dost spare me punishments which I
most justly deserve[,] listen oh listen I beseech thee to
the voice of this Thy Servant who would lift up her
heart in thanksgiving & pour out her soul in prayer to
Thee. With every power of my heart do I thank &
praise thee most holy God for the blessed hope and
promise of offspring which thou hast granted me. Oh
perfect[,] I beseech Thee[,] the great work of creation
which Thou hast begun in me & grant that the child
whom thou hast now quickened with the breath of
life may in due time be safely born into the world and
may thro Thy care & blessing be preserved to be a
comfort to its Parents and thro Thy grace & guidance
a glory to Thy Church. Preserve me if such be Thy
will thro' the pain and peril of Childbirth and spare
my life, enabling me thro Thy assistance to perform
my duties to Thee, to my best beloved and darling
Husband, and to the Child or Children with which
Thou mayst bless me. Enable me with a firm soul
and a steady heart to support the hour of my trial
feeling strong in Thy strength and resting firm
dependence on the promise

1

that Thou wilt allow no danger to befal me[,] no
accident or evil to come near to hurt me which is not
ordered in Thy wisdom for my clerical good & that
of those most dear to me. And on This hope do I
most heavenly Father wholly & entirely set my trust,
only beseeching Thee if Thou should'st think fit to
remove me from this world to bestow in mercy a
double portion of Thy tender care on my poor deso-
late husband and Motherless Child. For my Husband I
more especially entreat Thy protection. In mercy hear
the cry of my soul and be unto him a Father and a
Friend, a God of love and of Compassion[,] a Saviour,
a Comforter and a Redeemer. Most blessed Lord
forsake him neither by night nor by day. Take thy
watch about his path and about his bed and direct all
his ways. Thou alone dost know how fondly dear
This my husband is to me, how great is his tender-
ness, how true is his love. Thou knowest that I have
only been too prone to make him my earthly Idol and
thus have feared to offend Thee—Thou knowest also
that his constant tenderness has sweetened every hour
of my life & that

2

my only grief has been that his faith is not yet fixed
on the Saviour[,] the Rock of Ages in whom I trust &
to whom I make my prayer. Thine eye canst see what
no human eye has beheld & my secret sorrow is not

hidden from Thee. If it be then Thy will that I should
die in Childbirth my last prayer is that Thou shouldst
grant me in death the blessing I have so earnestly
desired in life and enlighten his mind so as to enable
him to see more clearly & to believe more fully spiri-
tual things. Grant that in becoming a Parent his heart
may be touched with Thy mercies and He may more
earnestly seek & desire Thy favour, and when he
seeks oh grant in mercy that he may find. Open to
him the veil of Thy sanctuary and engrave upon his
soul the blessed truths of Thy gospel so that the
Saviour may become to him his only hope & the
Saviour's blood seal him with the seal of redemption.
When he is in affliction and his widowed heart doth
mourn for heaviness do Thou send him that peace
which this world cannot give—comfort him with Thy
love and enable him to fix a steady eye of faith on the
hope which is my abiding trust & joy that we may
thro' our Saviour's merits be finally

3

re-united in the realms of bliss above—and[,] having
implored This Thy Heavenly Care and Watchfulness
for one who is more dear to me than tongue can
tell[,] I would beseech thee to calm my mind and
enable me to leave this earthly scene without regret
having made my peace with Thee. Now that I have
time left me on earth may I endeavour unceasingly
to finish the work of my salvation and to prepare my
mind simply to believe and that I may believe may I
be constant in prayer[,] fervent in spirit serving the
Lord. Now whilst I have health may I make the
Saviour my friend so that if the dangers of Child-
bearing are great I may bear them with a quiet soul
having made my peace with Thee. And in the hour of
death let not my heart be troubled but enable me to
enter Eternity with humble faith in that Redeemer
who is sufficient to save the greatest of sinners who
put their trust in him. But should I be spared to rise
from my bed of sickness and know the fullness of a
Mother's joy oh grant that I may live to praise and
magnify Thy Holy name for all Thy mercies towards
me. Grant me the assistance of Thy Spirit in enabling
me to watch over the body & soul of my Infant &
spare me to be a tender and loving wife to my
husband giving us both joyful and contented hearts
that we may gratefully receive the blessings of which
a Parent[']s heart must be full. And when possessing
the gifts—may we not forget the Giver of all good but
so walk in this world as to secure a continuance of thy
mercy both here and in the world to come. Through
the merits of Jesus Christ our Saviour & Redeemer—

July 8th. 1838.
Easden Reach.—

Account of Lord O[verstone] £500 and of £45 cash 6 10.		£	s	d
Sep. 1.	Alderslade	4	10	11
	James (Baker)	23	1	6
2.	J. Shaw	1	15	10
	Cory (Chemist)	29	14	3
	Lane poor sale	2	1	8
	Blake coals portion of bill	44	9	8
	Aldridge for sewer pipes	1	3	4
4th	Halling & Co. Waterloo House. portion of bill	40		
	Peacock. plated spoons	3	11	6
	Asprey	15	11	6
	Ellis (Ironmonger) portion of bill	30		
	Self	25		
	Hill	3	7	9
5th.	Pinnock portion of bill	30		
	Frodsham	1	5	2
	Webb draper	15	18	1
6th	Self	2		
	Houghton and Co	3	13	7
7th	Brook	3		
	Heal and Sons (Upholsterer)	12	19	10
	Total	304	9	1

Paid Bills		£	s	d
Brought over		304	9	1
Sep. 8th.	Beazley (Beer)	8	6	4
9th.	Sanders (Builder)	36	4	
14th.	Wellington (Chemist)	22	15	9
16th.	Gibson	3	10	
	Muswood (Farm)	40		
19th.	Waller (lloyd [*] education	23	13	8
	Fox (photo. mounts)	50		
	Lever (grocer)	30		
	Terry (wine)	8	12	
	29th Baily photo	6	13	
30	Balance	11	3	
Balance		545	6	10

For the existence of these bills to be explained I must also send you a list of the things paid the last two years which list you will see has swallowed up our whole income leaving nothing for these actual expenses of Baker[,] Butcher[,] grocer, furniture[,] our Builder and house builder, Iron monger[;] paid £117 in one cheque the other day[.]

Account of Julia Duckworth £112.15 and of 21 ———— 133.15		£	s	d
July 24th.	Stamps		2	1
	Self payment of small bills	50		
Aug. 3rd.	do.	45		
4th.	Postage			6
30th.	E. India Coy.	2	4	
Sep. 1st	Postage			6
	Stamps		2	1
5th	Mr. St. George	2	2	
30th	Balance	34	3	10
Total		133	15	

These are the paid bills
or portions of paid bills [which]
have swallowed up Lord O's £500
also Julia Duckworth[']s—112

Unpaid Bills	& Balances	£	s	d
Balance. Muswood farm butter, eggs[,] milk.		46	8	
do. of Lever grocer		33	8	5
do. of Blake coals		25		
do. of Pinnock		49	19	
do. Halling (Waterloo House[)]		153	[*]	
do. Elk's (ironmongers[)]		71	13	4
" Lambert Wine and Soda Water		83		
do. Fox		47		
Swan and Nash		16		
Field tailor. Henry's at Ventnor		44		
Orchard grocer		28		
Redmayne		82	19	
Thom. Sachs. Ewen's jewellery		17	19	
[illegible] & Glenny		32	5	
Palmer		29	16	6
Huntsman		39		
Mic. Cornelius		11	5	
Balance of Cory		20		
do. of Muswood up to this date		21	14	4
Total		£ 822		1

still unpaid
to payment of which
your £400 & Henry's
 345
 ——
 745 and the balance (a little you see
 we have[)]

*Illegible.

Freshwater Bay. October 19th. 1871.

My own cherished Har

By the French packet of last week I wrote you a letter chiefly on business. This time altho' I have a great deal to say on business matters I will not enter on them until I have given you some home news. I am quite at a loss to acct. for the delay and irregularity of my August letters to Ceylon. One mail you did not receive any and the next mail two came together and you say you think the delay arose because one letter was registered. It is the Registry which generally ensures exactness of delivery, as to date[,] for I have known Postal Authorities [to] refuse to register when they could not guarantee dispatch on the day of delivery. It is well indeed that

1

I telegraphed Topsy's [wife of Ewen, one of Mrs. Cameron's sons] arrival as thus you were all spared all anxiety. My letter to Ewen will give you in detail the visit she and little Aubrey [Ewen and Topsy's child] made to their Island home yesterday[,] to us quite an eventful visit as being of such deep & tender interest. The Baby is a sweet little Boy. Amongst English Babies of the same age he would now take his place as a fat and well developed Child—yet in spite of all this progress I cannot conquer a certain anxiety abt. him. He has not to my eye a Baby look—his expression is "o'erinformed". Serious—sweet and wise—but not the look of a Baby. He smiles and even audibly laughs[;] after that he hangs his little head on one side and looks precociously grave[.] Mine however is only the result of an hour's observation. I only

2

wish it were possible to me to see him more closely & completely but my bronchitic tendencies make it difficult for me to cross to and fro. Topsy made a great effort in bringing him yesterday & she gave proportionate delight to all. The Grandfather was quite delighted & attendri by his godson and admired him very much. Topsy looked very blooming tho I think she takes a little too much out of herself even as if she were one of us. She is however very temperate in her feelings. She was told what was quite a fact[,] "that I loved her so I felt as if I could lay down my life for her".

3

She smiled and said "I hope Mummie that won't be required of you." I am afraid the broken visits she can only give us will not quite establish her knowledge and feeling of intimate confidence. I should like her to love me as she does her own Parents[;] perhaps that is expecting too much. She has not yet met Dudy [Mrs. Cameron's daughter?]. I believe and hope

that they will love each other very truly when they do meet. Our poor Dudy has been again suffering great depression from threatening of a miscarriage. She is just beginning to get better—but I dread for her a miscarriage and I also dread a confinement. [Not knowing which will try her shattered nerves the most.**]

4

Your father is very well thank God. He is writing you an answer to yr. Letter which will be useful to you as he sanctions of course your keeping of the £107. (Mr. Stopford's money) for the false survey causing excess of land to have been sold in Dimbola [a Cameron property]. That survey was charged at an immoderately high price and the surveyor ought to refund some of the money he charged seeing his mistakes have led to all this trouble. Don't you think he *ought* tho' it is not likely that he will.

5

Of course no legal measures should be taken that would be an endeavour "à pure perte[.]" I say it might be represented to him. Yr. father says "What good would come of representing it to him. In the honourable professions *custom* not honor is the standard of conduct. A surgeon cuts off a man's leg, the man dies of the operation and the surgeon charges the impoverished and distressed widow the same sum as if he had operated skilfully and restored her husband's health & to the power of supporting his now penniless family. Here honor interferes where the legal claim cannot be questioned.["] I often think of these cases of the poor[;] indeed

6

"the deep sighings of the poor" is ever before my mind and heart. I do not mean the indigent poor because they have hospitals and infirmaries—but there is a class that public charities do not include & private charities never reach; for them I feel so deeply that whenever I am ill, instead of its being possible for me to grumble then the sense of all my mercies *always* comes most strongly upon me. The comfortable

7

bed, the quiet room, the affectionate attendance of old E [a servant], the sympathy of Madonna [Mary Hillier, Mrs. Cameron's parlormaid], the exemption from toil, the power to have luxuries and food contrasted with the fate of Women in some cases better than I am, who have to get up to the wash tub, to lie on a pallet in draughty damp hovels, to bear with screaming Babies and drunken husbands and to sink for want of rest and nourishment.

8

But I [am] not going to generalize and moralize when you long to know individual things of interest[;] only just having been laid up with an attack of a Bronchitic

nature (not amounting to Bronchitis[)] these thoughts have been constant with me and I now write from my bed grateful for this quiet and prudent Nook. The same bed on which you, and all of you have sat by me, the same bed on which you used to chant Sun of my Soul realizing to me the beautiful tones & thoughts & words—also "abide with me"[—]would you could have abided

9

with me, also you used to read Flower[,] Fruit and Thorn pieces and appreciate all the dry humour and sentiment of those matchless Vols. Now again to other subjects[.] We have every day now under discussion what is to be Henry's [one of Mrs. Cameron's sons] destiny and upon my heart the question presses with all its momentous realities. If he is directed aright all his finer energies may come out, all his virtues strengthened, & his one fault of mental indolence be strangled ere it attain maturity.

10

If he is put upon a wrong scent his brightness may vanish & he may become soured suddenly & hypo-condriacal, quite an altered Henry divested of all his own sweet original joy, in which respect he very much resembles you & he resembles you too in a *reliable* straight forwardness. Would he resembled you in choice of a line of duty over pleasure—in the everyday life—however "I am not to praise you". I do not

11

like even in joke that you should say that your swan may turn out a goose and that you may be driven some day to comment etc. etc. words too terrible to write even in joke[.] You are not now passionate as you were as a Child and you are all pitiful and merciful to the poor blacks against whom you would never raise a hand or I should fear a blow on frames so organized that a touch might create death upon brains & livers ripe for congestion.

12

Two things have occurred lately which have set up a train of anxious and painful thought in me. One event is to see an aged man[—]a Minister of God's word—a recluse—a student—a man whose life has been spent in the teaching of youth and in the hon-ourable pursuit of literature just at the close of his life without provocation and without any manifest insan-ity brutally and premeditatedly one Sunday afternoon murder his aged Wife of 63 and then apply himself for three days to the systematic and *complete* & perfect arrangement of all his papers and affairs. It would seem as if he had previously felt the provocation or irritation & this is the only light as yet thrown on the matter. Probably after that big Sunday dinner there was some undue pressure on his brain causing a short sudden paroxysm of

13

madness. This is the only explanation I can give. It is a case of remarkable interest viewed judicially. The only instruction I can draw is for self Govt. to keep out of sight causes & subjects of ungovernable irri-tation. I send you the Paper. Passion becomes a matter of habit and its very first gusts should be checked—and every day should be an exercise of *subduing* irritability

14

till calm becomes the *climate* in which the temper & soul lives. The other event I speak of is the Fire at Chicago. Here we see the utter destruction of a whole city, a city of uncommon luxury & refinement[,] prodigious wealth & masses of human beings all brought to ashes. All the teeming life of baby, Child, Man[,] Father, Grandfather, Patriarch, Sire,

15

Girl, Mother, Grandmother, aged, Maiden—all buried and buried in one Mass—"cartloads of dead bodies." All the industry & wealth of the City[,] every thing of the Past, present and unrealized Future, *all* sacrificed thro' the carelessness of one Boy entering one stable with a light!—This is a visible result of one act set *before our eyes* in our own day. If this then is per-mitted by an Almighty

16

ruler of events to be the vast consequence & over-whelming calamity resulting fm. one act called by the world accident[,] What in the Moral World May alike result from *one action*—how may one word—or one deed alike effect thousands and tens of thousands in its after consequences[,] one illegitimate birth affect a race!—

17

Every hour of every day I rejoice in the pure and happy marriage which has secured to Ewen his Treasure and I only yearn & long for the time when you be equally blessed. I have been reading carefully two books which I will send to you next mail. They will put before you plainly all the Service that is now thrown open to the whole World for open competition[,]

18

the various ages at which one may compete[,] the salaries to be acquired etc. etc. If you can get no correspondingly good pay in Ceylon and are so tied by the leg that leave is impossible[,] query[:] is not the English C. S. better. When you all [were] young you would none of you choose clerkships in Govt. office and each in turn resisted my appeal to you to try for these[;] how I did entreat Ewen too—now you see

19

that from a Colonial office clerkship Irving gets a pick appt.[;] from a Colonial office clerkship Birch is sent

out as a governor. Henry Taylor is very much averse to changing one's line of life and there is Instability if it proceed fm. restlessness[—]a very great evil[—]but if it proceed fm. experience & sober trial I think the case is quite different. There can be no harm in my sending you the Books in question[.]

20

As for your letter about the sale of Rathoongodde [a Cameron property in Ceylon] I thought it a most reasonable letter but as Ewen[']s letters on the subject have none of them yet arrived of course the subject is not yet broached to the Trustees—Nor with any shadow of justice could Rathoongodde be sold without securing to *us* as well as to Charlie Hay [one of Mrs. Cameron's sons]

21

some portion of the annuity which is justly our due[.] To give after deducting Charlie's annuity say an extra £3,500 represented by the sale of Rathoongodde to Ewen's and Birdie[']s [another nickname for Ewen's wife] marriage settlement would be wholly unfair to the other children & only aggravate the present unfairness of the division which even now exists. Take from it our

22

annuity or even some portion of our annuity & the unfairness ceases to be so extreme and this of course must be done. If the sale of Rathongodde added Two Thousand pounds to Ewen's and Topsy's marriage settlements I think they may both be very well content indeed provided they both wish it to be sold. This would then go to constitute a sum of Five Thousand Pounds settled in all by Ewen upon his Wife.

23

Your Father says that I am responsible for the largeness of Ewen's share[,] that *he* never wanted to give him Rathoongodde or to give him that last block value[—]£1800 was it not[—]which went to make Rathoongodde clear of debt in order to make the deed of gift at marriage good. It is perfectly true that all this was my doing. I

24

rejoiced & do so much rejoice over the marriage that I would gladly for Ewen's sake & for the sake of any one of my sons sacrifice any thing I could sacrifice at the Altar of Marriage with any girl noble in mind & in nature. That is you know the real nobility I prize above all things.

25

But also it must be remembered that I did make a reservation and that reservation *must* be adhered to in part if it cannot be wholly paid—for even as I gave Rathoongodde which I might have kept for myself accord. to Ceylon law, So I would yield to any of you upon marriage these Freshwater houses which belong

to you, to Charlie and to Henry, but then I must also give something of annuity for

26

the other Brothers. Henry has without hesitation yielded up to his last sum of £345 recd. from you and I have got him this Mail to copy for you a list of things paid and things owing still which will show you at once why we use his £345—& why we have asked of you Four Hundred £400. I hope ere this you will have telegraphed to us to tell us you could spare this or better still that Ewen has sent it to us & that you are hoarding *all* your six hundred to return home.

27

Charlie Hay has no readiness to yield up any portion of his money—and what he will do with it as it falls due is yet to be proved. At present his ways & modes of life are to me lamentable. He never opens a book, never does any copying work or any work of any kind—strolls away to Billiards after his mid day breakfast or hires a trap & drives and as the air is good for him I do not object altho' a walk would be far better. He often dines with friends of his at the Hotel paying his share of the dinner. An idle fellow, Cooper of the R. A. [if only!!**] is his great friend now

28

and *always* he and Henry spend the whole evg. at the Billiard Table! Yesty. Evg. to my exceeding delight they returned at ten P.M.[;] consequently Henry was at home to speak to the Rural Dean who came in for half an hour of the Evg. & talked for my sake to Henry abt. his prospects & as [to] being a land agent

29

Henry would prefer [it] to a Govt. situation as providing open air exercise, Mr. Wilson is going immediately to enquire of land agents whom he knows if they will take Henry as a Pupil. It is often a charming post. Of course with our Interest a land agent worthy and capable might be useful to a Peer having landed Estates of whom

30

so many are my personal friends but then he *must become* capable of book keeping and some surveying. Lords Somers, Elcho[,] Lichfield, Dalkeith[,] Lilford[—]a great many might give Henry a Berth and it is not peers only or Peers chiefly who have landed Estates. Charlie is full of the idea he can be made Queen[']s Messenger or House Messenger with a touch of my wand for the asking.

31

Henry Taylor—Herbert Fisher [the husband of Mrs. Cameron's niece] and Charlie Norman [Mrs. Cameron's son-in-law] all agree that I should use the money my children have to pay up all debt first of all—but why you & Henry should alone bear the burden I do not see. More particularly Henry is at this

moment far more in need of his money than Charlie can be of whom nothing is required but to stay in his home and be content with his home and turn his leisure to some acct. in improving himself if he be capable of so doing!!! An Artillery Dr. here has been a comfort to me—he says he has seen cases

32

of neuros-bone & that he is convinced that Charlie's neuros is neither constitutional or mercurial but has simply arisen from the one or two decayed teeth on one side & one on the other. He had three teeth extracted with abscess at the root—that the pus of the one abscess if neglected would spread and cause neuros which also wd. spread[.]

33

Now anyone who saw the drugged condition of self administered opium for tooth ache in which I found Charlie and who saw the unspeakable neglect of himself which followed for weeks afterwards when no earthly persuasion of mine or Drs. could induce him *even* to rinse or gargle his mouth when pus flowed unceasingly mixing with all his food

34

& even making himself & his whole rooms almost intolerable[.] Anyone who had seen this as Henry and I did & seen & suffered in vain would bear testimony to the probable history of neuros assigned by Dr. Babington of the R. A. who did not know all this but who says now Charlie could not be as well as he is if the neuros arose from deeper reasons.

35

Even now the Doctors here prophesy Pyeuria or poisoned blood for him (such as our Dudy has from

other causes connected with her confinement) if Charlie will not gargle, will smoke and will neglect to purify the foul breath & foul matter in his mouth. He goes out to dine at 7—comes home at 12—once to gargle—goes home to bed.,

36

and only awakes again at 12 next noon to gargle when he is warned & told he ought to gargle every hour by day and two or three times in the night. Henry and Loo Prinsep are going over to a Ball tomorrow night to Mrs. St. Barbes. I am going

37

to Town with Charlie to get Hewitt[']s opinion next week. I have delayed on purpose. Nature is *accomplishing* her work[:] the dead bone is almost disengaged[;] just one chip so broad of the gum remains to be disengaged

38

and it will come naturally out and *healthily* if he would lead a prudent wholesome life & purify his mouth. You see my beloved Ewen and Har I have a *great great deal to suffer* and to be anxious about. In Henry I have a trust for the future tho the present is so unsatisfactory.

39

And now my Treasure I must leave you and turn to Ewen to describe his beloved Wife's visit of yesterday with the precious little Aubrey. I hope this letter will reach your hands safely. I wish it could be *all* brightness. Next month I hope I may tell you that Henry at least is in a way to redeem the time[.] God bless and preserve you ever and ever and ever. prays your devoted Mother

***These phrases are written in the margins.*

Farewell of the Body to the Soul

Sweet soul of mine! my closest dearest Friend
Forgive me ere we part all injury done
All warfare now between us has an end
Thy frail companion now his race has run

How oft when soaring with a wish divine
I've dragged thee down, and laid thee in the dust
Tricked with false promise glorious hopes of thine
Dwarfed all thy stature, made thy brightness rust

And thou didst ne'er resent, but oft and oft
In the night watches would'st invoke me still
In accent loud and strong—or sweet and soft
To give thee liberty to have Thy will

How oft in playful combat we would strive
If sweet cajolery would win the race
Now thy pure essence free of me shall live,
We part sweet soul! Smile on my pallid face.

Thou wing'st thy flight, art thou of me so tired?
Let us be friends at least—oh why that start?
Thou find'st thy freedom oft so much desired—
Forgive and love me—flown—distinct—apart—

20th Nov. 1876.

We have now been one year in Ceylon. I may there-
fore ascribe to my jottings the dignity of experiences.
My first impressions having been modified—con-
firmed or effaced—My wonder for instance has been
tamed but not my worship—The glorious beauty of
the scenery—the primitive simplicity of the Inhabi-
tants & the charms of the climate all make me love
and admire Ceylon more and more. I do not think our
severe Island of England at all recognizes the charms
of her Tropical Sister[.] They have only to be studied;
for all the weak and fragile Inhabitants of our North-
ern Climes to flock here with the Instinct of the
swallow and to find a sure redemption from every
disease of lungs—chest—throat—larynx[—]and a cure
for all pulmonary delicacy combined with exquisite
enjoyment: for dead indeed must be the soul who is
not satisfied with Nature as here presented to the eye.
But it is not my mission to preach[;] it is my desire to
persuade and to convince and I ask only impartial and
reasonable attention—

_I

We arrived in the Island of Ceylon this day year—
My Husband at 81 years of age had benefited very
much by the sea voyage & after having been when
in England for the previous years in a condition of
apathy almost amounting to torpor he suddenly
awoke to some use of his limbs and senses, and his
activities mental and physical have so progressed and
perfected during his year's residence that now he
walks and rides with vigour and ease and not only
reads for several consecutive hours but converses
with all the brilliancy as to repartee and memory as to
anecdote and quotation, for which he was remarkable
in the prime of his life. My own health has also bene-
fited much. In England during 8 months of the year
I was never secure against sudden and dangerous
attacks of Bronchitis—such illnesses and ailments are
unknown in this sunny Land, where East winds are
not spoken of and cough and catarrh never heard.
The voyage was not in itself favourable to me as the
two months that preceded my leaving England were
months of severe bodily fatigue and much mental
anguish

₂

CHECKLIST OF OVERSTONE IMAGES

The III photographs presented by Julia Margaret Cameron to Lord Overstone have been dismounted for conservation purposes; all are illustrated in this checklist. The first number in each entry indicates the Museum's folio number for that image; breaks in the sequence represent blank pages. The number in parentheses immediately following the Museum's folio number is Mrs. Cameron's pagination, inscribed by her in ink above each photograph. Several of her numbers are lacking (8, 9, 22, 41, 42, 47, 48, 105, 107), while number 103 is given twice. It is unclear whether the lacunae represent errors in numbering or whether the leaves were removed by a prior owner. The sequence of the photographs and the arbitrary placement of certain important images on the verso with no facing image raise questions as to why the photographs were arranged in the sequence in which they were found. The problem is compounded by the fact that the sequence established by Mrs. Cameron in the list of titles is different from the actual sequence in the album. One conclusion is that she did not mount the photographs herself.

All works illustrated in this volume are albumen prints unless indicated to the contrary.

1r
Table of contents

2r (JMC 1)
Alfred Tennyson/
Freshwater/May 1865
H: 25.6 cm (10 1/16"); W: 21 cm (8 1/4")

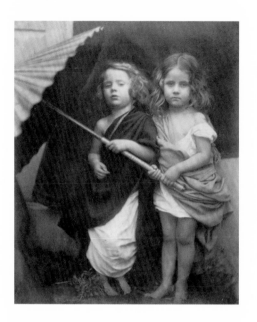

3r
The Anniversary
Signed: l.r., *Julia Margaret Cameron*
Fragmentary blind stamp: ... *sold by*
Messrs Colnaghi...
H: 27.5 cm (10¹³⁄₁₆″); W: 20.7 cm (8⅛″)

4r (JMC 2)
Paul and Virginia
H: 25.4 cm (10″); W: 19.9 cm (7¹³⁄₁₆″)

4v (JMC 3)
Henry Taylor/
FreshWater/1864
H: 24.9 cm (9¾″); W: 19.5 cm (7¹¹⁄₁₆″)

5r (JMC 4)
Henry Taylor/
FreshWater/June 1st, 1865
H: 24.9 cm (9¾″); W: 19.7 cm (7¹¹⁄₁₆″)

5v (JMC 5)
Wm. M. Rossetti/
Little Holland House lawn/May 1865
H: 25.4 cm (10″); W: 20 cm (7⅞″)

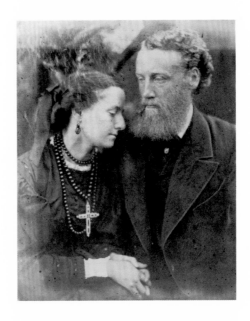

6r
Untitled print
Signed: l.r., *Julia Margaret Cameron*
H: 25.4 cm (10″); W: 19.9 cm (7¹³⁄₁₆″)

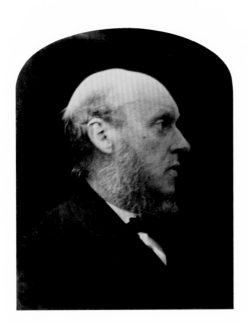

7r (JMC 6)
James Spedding/
Whitsuntide 1864/Hendon lawn
H: 23.2 cm (9⅛″); W: 17.9 cm (7″)

7v (JMC 7)
Hardinge Hay Cameron/
FreshWater/May 1864
H: 24.9 cm (9¾″); W: 19.5 cm (7¹¹⁄₁₆″)

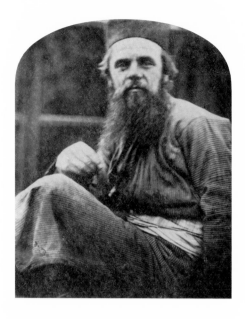

8r (JMC 10)
Wm. Holman Hunt/
1864/Hendon lawn
H: 22.9 cm (9"); W: 17.8 cm (7")

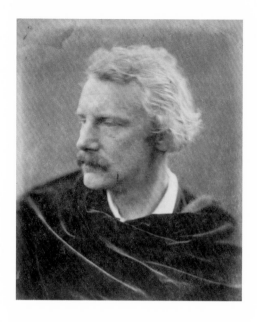

8v (JMC 11)
Sir Coutts Lindsay/
Lawn of Little Holland House/1865
H: 25.4 cm (10"); W: 20.2 cm (7¹⁵⁄₁₆")

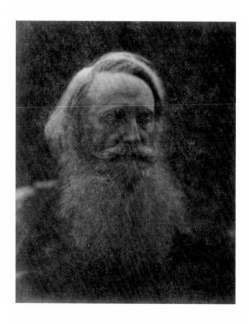

9r (JMC 12)
Henry Taylor/
FreshWater/1864
H: 24.9 cm (9¾"); W: 19.5 cm (7¹¹⁄₁₆")

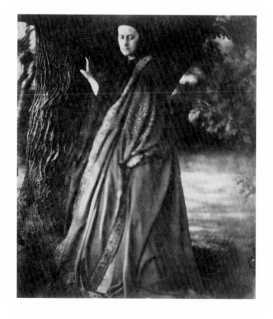

9v (JMC 13)
Lady Elcho/A Dantesque Vision
[in pencil]/
Lawn of Little Holland House/May 1865
H: 25.8 cm (10³⁄₁₆"); W: 21.6 cm (8½")

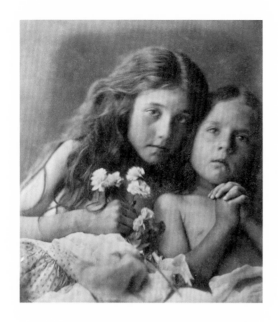

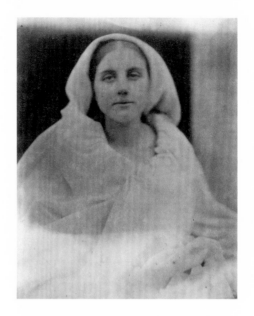

10r
The red and white Roses
Fragmentary blind stamp: . . . *sold by
Messrs Colnaghi* . . .
H: 27 cm (10 ⅝″); W: 22.8 cm (8 ¹⁵⁄₁₆″)

11r (JMC 14)
*"Joy"/Kate Dore/
FreshWater/1865*
H: 24.8 cm (9 ¾″); W: 19.6 cm (7 ¹¹⁄₁₆″)

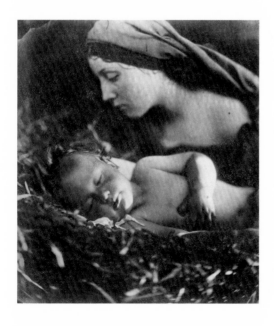

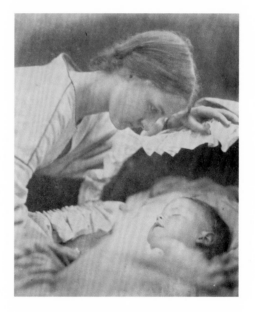

11v (JMC 15)
*Light and Love/
FreshWater/June 1865*
H: 25.3 cm (9 ¹⁵⁄₁₆″); W: 21.4 cm (8 ⅜″)

12r (JMC 16)
*The first born/
FreshWater/April 1865*
H: 24.8 cm (9 ¾″); W: 19.5 cm (7 ¹¹⁄₁₆″)

12v (JMC 17)
Alice/
FreshWater/1864
H: 25 cm (9¹³/₁₆″); W: 21.8 cm (8⁹/₁₆″)

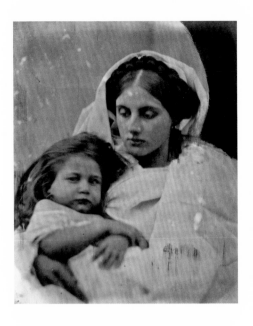

13r (JMC 18)
La Madonna Vigilante/
FreshWater/1864
H: 25.5 cm (10″); W: 20 cm (7⅞″)

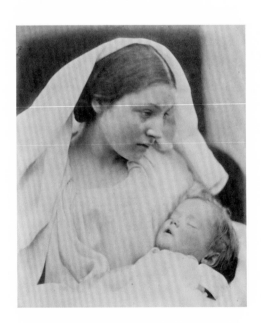

14r (JMC 19)
La Madonna Riposata/Resting in hope/
FreshWater/1865
H: 24.3 cm (9⁹/₁₆″); W: 19.9 cm (7¹³/₁₆″)

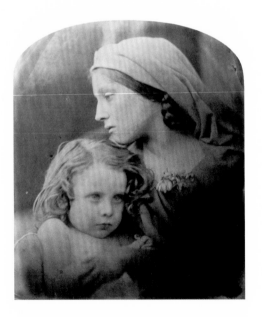

15r (JMC 20)
La Madonna Aspettante/Yet a little while/
FreshWater/1865
H: 24.5 cm (9⅜″); W: 19.9 cm (7¹³/₁₆″)

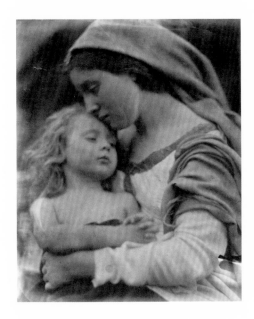

16r (JMC 21)
Grace thro' Love/
FreshWater/1865
H: 24.8 cm (9¾"); W: 19.6 cm (7¹¹⁄₁₆")

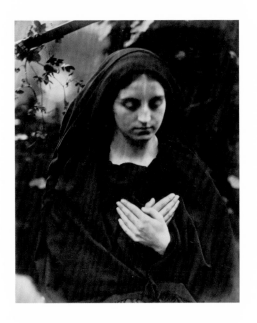

17r
Il Penseroso
H: 25.5 cm (10"); W: 20 cm (7⅞")

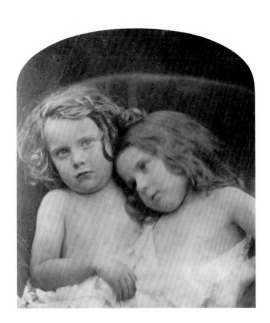

18r (JMC 23)
The Infant Bridal/
FreshWater/1864
H: 23.3 cm (9⅛"); W: 19.5 cm (7¹¹⁄₁₆")

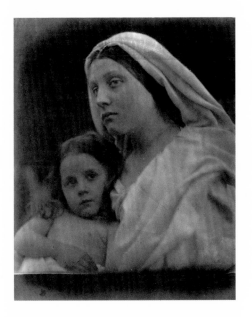

19r (JMC 24)
Peace/
FreshWater/1865
H: 24.8 cm (9¾"); W: 19.6 cm (7¹¹⁄₁₆")

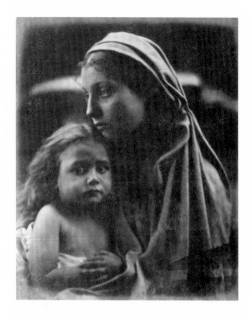

20r (JMC 25)
La Madonna Adolorata/Patient in Tribulation/
Fresh Water/
H: 25.4 cm (10″); W: 20 cm (7 7⁄8″)

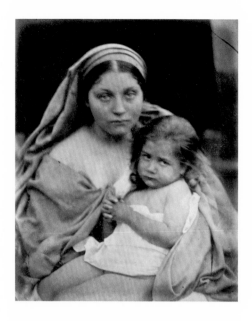

21r (JMC 26)
Goodness/
one of a series of nine illustrating the fruits
of the Spirit
H: 25.4 cm (10″); W: 20 cm (7 7⁄8″)

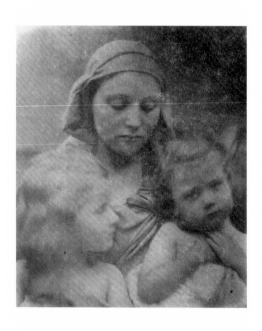

22r (JMC 27)
Contemplation
H: 23.7 cm (9 5⁄16″); W: 19.5 cm (7 11⁄16″)

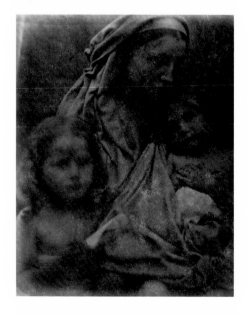

23r (JMC 28)
Love/
FreshWater/1864
H: 25.5 cm (10″); W: 19.6 cm (7 11⁄16″)

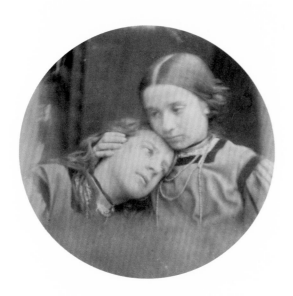

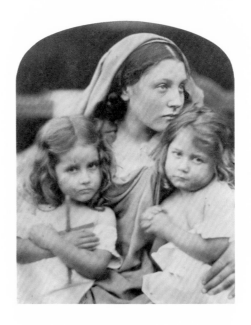

23v (JMC 29)
Isabel & Adeline Somers/My Sisters Children/
Cromwell Place Balcony/1864
Diam: 22.7 cm (9″)

24r (JMC 30)
Faith/
FreshWater/1864
H: 23.8 cm (9 3/8″); W: 18.5 cm (7 1/4″)

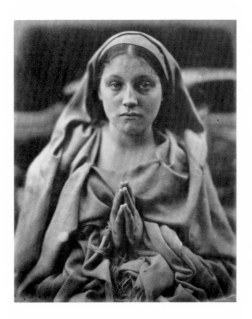

25r (JMC 31)
Prospero/(Life)/study of head from
Henry Taylor/
May 1865/FreshWater
H: 26.8 cm (10 1/2″); W: 21.4 cm (8 3/8″)

26r (JMC 32)
St. Agnes/
FreshWater/1864
H: 25.5 cm (10″); W: 20 cm (7 7/8″)

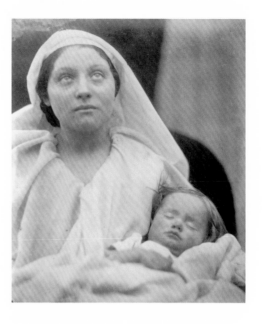

27r (JMC 33)
The Water Babies/
FreshWater/1864
Diam: 20.8 cm (8⅛")

28r (JMC 34)
La Madonna Esattata/Fervent in prayer/
FreshWater/1865
H: 24.5 cm (9⁹⁄₁₆"); W: 19.9 cm (7⅞")

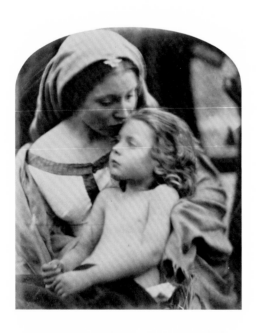

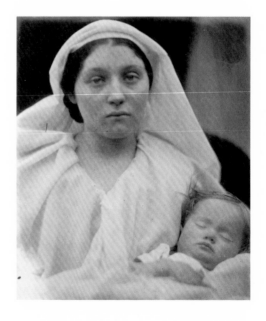

28v (JMC 35)
Blessing and Blessed/
FreshWater/1865
H: 25 cm (9¹³⁄₁₆"); W: 20.1 cm (7⅞")

29r (JMC 36)
La Madonna della Pace/Perfect in peace/
FreshWater/1865
H: 24.1 cm (9½"); W: 19.9 cm (7⅞")

29v (JMC 37)
Henry Taylor
H: 25.9 cm (10¼″); W: 21.8 cm (8⁹/₁₆″)

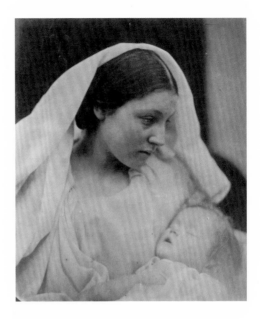

30r (JMC 38)
La Madonna Riposata/Resting in hope/
from another Negative than the one seen page 19/
FreshWater/1865
H: 24.5 cm (9⁹/₁₆″); W: 19.9 cm (7⅞″)

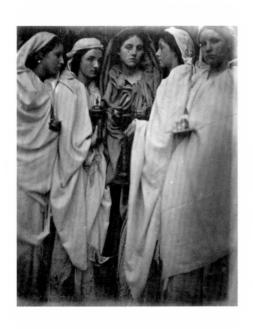

30v (JMC 39)
The five Wise Virgins/
FreshWater/1864
H: 25.4 cm (10″); W: 20 cm (7⅞″)

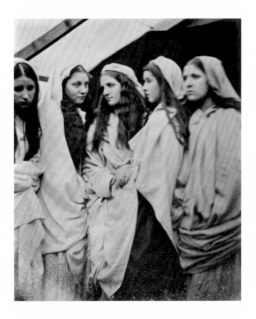

31r (JMC 40)
The five foolish Virgins/
FreshWater/1864
H: 24.8 cm (9¾″); W: 19.9 cm (7⅞″)

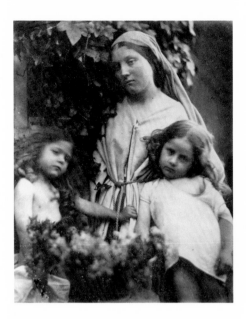

32r (JMC 43)
Spring/
FreshWater/May 1865
H: 25.4cm (10″); W: 20 cm (7⅞″)

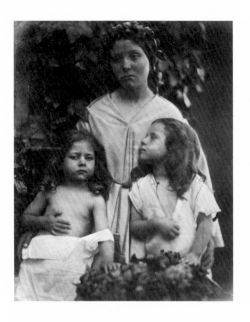

33r (JMC 44)
Spring/
FreshWater/May 1865
H: 25.3 cm (9″); W: 20 cm (7⅞″)

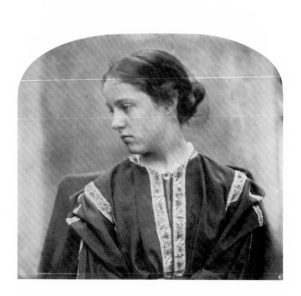

33v (JMC 45)
Magdalene Brookfield/
Little Holland House Lawn/May 1865
H: 22.2 cm (8¾″); W: 24.3 cm (9½″)

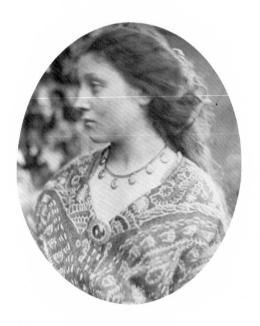

34r (JMC 46)
Sappho/
FreshWater/May 1865
H: 22.1 cm (8¹¹⁄₁₆″); W: 17.5 cm (6¹⁵⁄₁₆″)

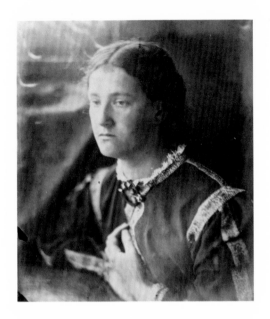

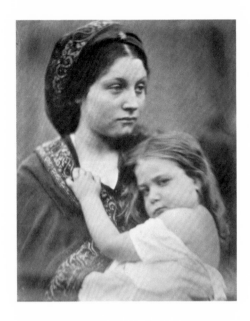

35r
Julia Herschel/now Mrs. McClear
Signed: l.r., *Julia Margaret Cameron*
H: 25.6 cm (8¾″); W: 21.1 cm (9½″)

36r (JMC 49)
*La Madonna della Ricordanza/Kept in
the heart/
Fresh Water/1864*
H: 25.5 cm (10″); W: 20 cm (7⅞″)

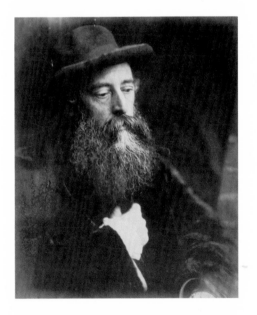

37r
"I promise"
Fragmentary blind stamp: ...*sold by
Messrs Colnaghi*...
H: 26.7 cm (10½″); W: 21.2 cm (8⅜″)

38r (JMC 50)
*G. F. Watts/
FreshWater/1864*
H: 25.4 cm (10″); W: 20 cm (7⅞″)

39r (JMC 51)
St. Agnes/
FreshWater/1864
H: 25.5 cm (10″); W: 19.9 cm (7¹³⁄₁₆″)

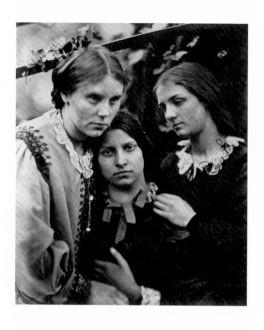

40r (JMC 52)
The disappointment/
Lawn Little Holland House/May 1865
H: 26.2 cm (10⁵⁄₁₆″); W: 21.4 cm (8⁷⁄₁₆″)

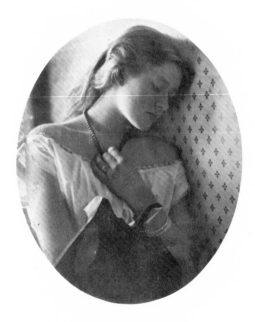

41r (JMC 53)
Sadness/
FreshWater inside cottage/1864
H: 22.1 cm (8¾″); W: 17.5 cm (6¹⁵⁄₁₆″)

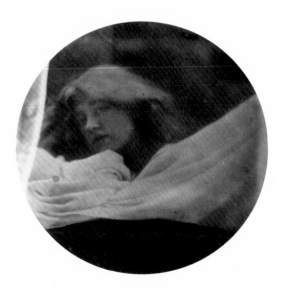

42r (JMC 54)
The South West Wind/(study for the same)/
Cromwell Place Balcony. Kensington/1864
Diam: 20.4 cm (8³⁄₁₆″)

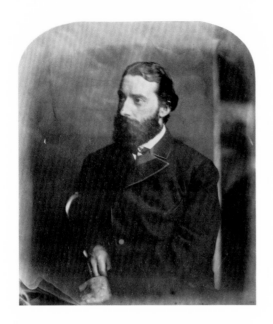

42v (JMC 55)
C. L. Norman/
Little Holland House/1865
H: 26.1 cm (10⁵⁄₁₆″); W: 21.6 cm (8⁹⁄₁₆″)

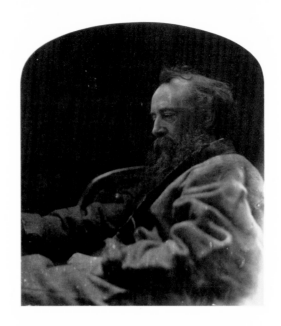

43r (JMC 56)
G. F. Watts/
Cromwell Place Balcony/1864
H: 21.8 cm (8⁹⁄₁₆″); W: 19.5 cm (7¹¹⁄₁₆″)

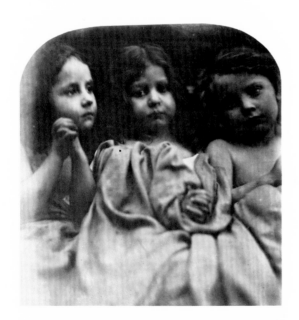

43v (JMC 57)
Seraphim and Cherubim/
Fresh Water/1864
H: 23.4 cm (9¼″); W: 21.6 cm (8½″)

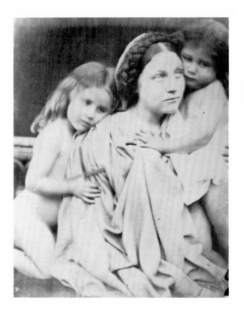

44r (JMC 58)
Gentleness/one of the series of the nine
"fruits of the Spirit"/
FreshWater/1864
H: 25.2 cm (9¹⁵⁄₁₆″); W: 19.3 cm (7⁵⁄₈″)

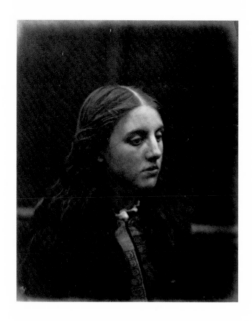

45r (JMC 59)
Suspense/Kate Dore/
FreshWater/1864
H: 25.4 cm (10″); W: 20 cm (7⅞″)

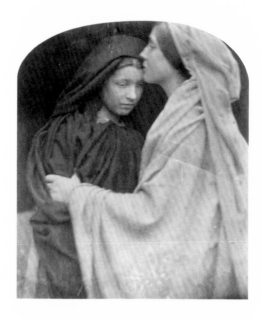

46r (JMC 60)
The Salutation/
FreshWater/1864
H: 21.6 cm (8½″); W: 17.8 cm (7″)

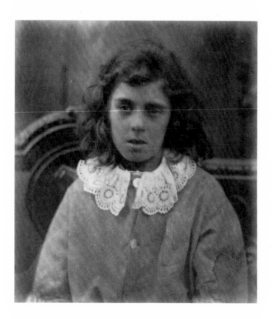

47r (JMC 61)
Lionel Tennyson/
youngest Son of the Poet Laureate/
FreshWater/1864
H: 23.4 cm (9³⁄₁₆″); W: 19.9 cm (7¹³⁄₁₆″)

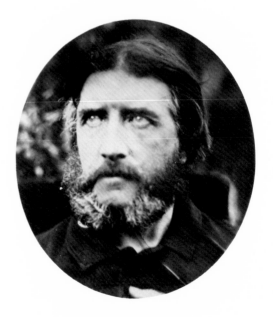

48r (JMC 62)
Henry Halford Vaughan/
Hendon Lawn/1864
H: 19.4 cm (7⅝″); W: 16.4 cm (6⁷⁄₁₆″)

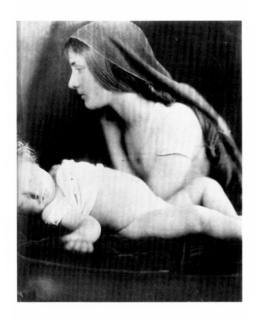

48v (JMC 63)
The Shunamite Woman and her dead Son/
FreshWater/1865
H: 27.1 cm (10⅝″); W: 21.4 cm (8⅜″)

49r
Aged 94/Taken on the Anniversary of her
72d Wedding day
Fragmentary blind stamp: ... *sold by*
Messrs Colnaghi ...
H: 24.8 cm (9¾″); W: 19.5 cm (7¹¹⁄₁₆″)

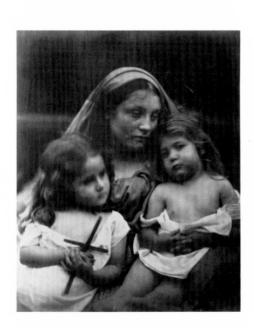

50r (JMC 64)
Long-suffering/
"Fruits of the Spirit"/
FreshWater/1865
H: 25.4 cm (10″); W: 19.9 cm (7¹³⁄₁₆″)

51r (JMC 65)
The Recording Angel/my especial joy!/
FreshWater/1864
H: 25.4 cm (10″); W: 19.9 cm (7⅞″)

52r (JMC 66)
First Ideas/
FreshWater/1865
H: 24.8 cm (9¾″); W: 19.9 cm (7¹¹⁄₁₆″)

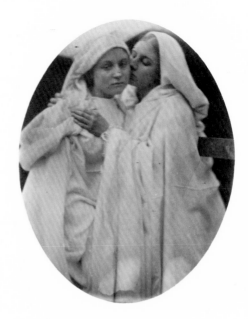

53r (JMC 67)
"Flos and Iolande"/
from St. Clements Eve/
FreshWater/1864
H: 25.8 cm (8⁹⁄₁₆″); W: 20.1 cm (7¹⁵⁄₁₆″)

53v (JMC 68)
Ewen
H: 11.7 cm (4⅝″); W: 9.4 cm (3¾″)

54r (JMC 69)
Annie/my very first success in
Photography/
January, 1864
H: 18 cm (7¹⁄₁₆″); W: 14.3 cm (5⅝″)

55r (JMC 70)
Water Babies again/
FreshWater/1864
H: 14.1 cm (5½"); W: 20.6 cm (8⅛")

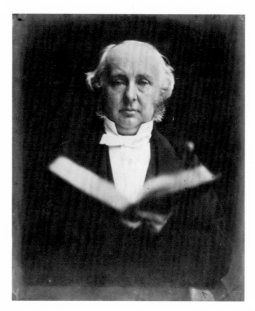

55v (JMC 71)
Professor Jowett/
Fresh Water/1864
H: 26.5 cm (10⁷/₁₆"); W: 21.6 cm (8½")

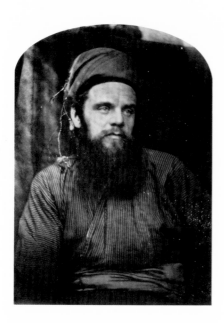

56r (JMC 72)
Wm. Holman Hunt/
Lawn at Hendon/1864
H: 25.4 cm (10"); W: 17.8 cm (7")

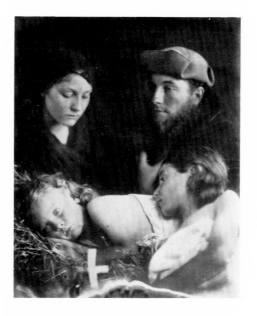

56v (JMC 73)
A Christmas Carol/
FreshWater/May 1865
H: 26.4 cm (10⅜"); W: 21.4 cm (8⁷/₁₆")

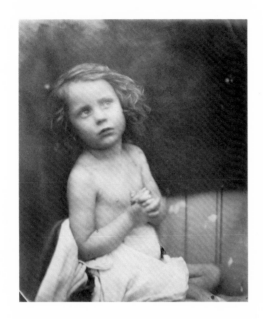

57r (JMC 74)
The Infant Samuel/
Fresh Water/April 1865
H: 24.7 cm (9¾″); W: 20 cm (7⅞″)

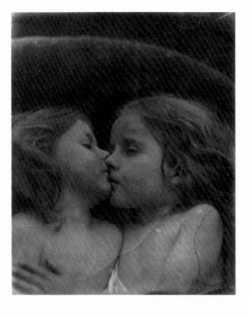

58r (JMC 75)
The Double Star/
FreshWater/April 1864 [the final "4" was
written over a "5"]
H: 25.4 cm (10″); W: 20 cm (7⅞″)

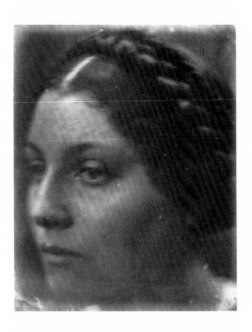

59r (JMC 76)
Mary Madonna/actual size Life/
FreshWater/1864
H: 26.7 cm (10½″); W: 20.8 cm (8 3/16″)

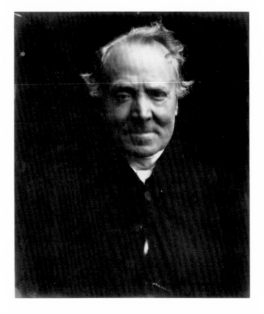

60r (JMC 77)
Rev. J. Isaacson/
Rector of FreshWater/
1864
H: 25.9 cm (10 3/16″); W: 20.9 cm (8¼″)

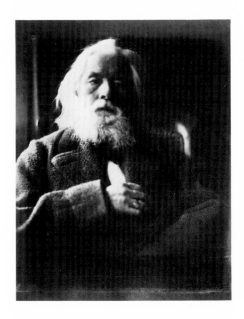

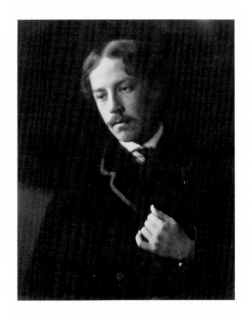

60v (JMC 78)
Charles Hay Cameron/
FreshWater/1864
H: 29.1 cm (11½″); W: 22.3 cm (8¹³⁄₁₆″)

61r (JMC 79)
Ewen Wrottesley Hay Cameron/
FreshWater/1865
[mounted over another photograph]
H: 25.5 cm (10″); W: 20.1 cm (7⅞″)

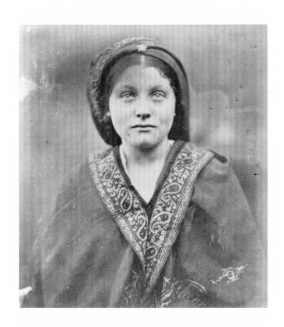

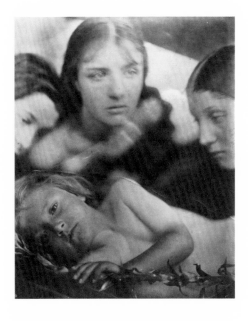

62r (JMC 80)
Hope/
FreshWater/1864
H: 23.7 cm (9⁵⁄₁₆″); W: 20.9 cm (8¼″)

62v (JMC 81)
Hosanna/
FreshWater/May 1865
H: 28.2 cm (11⅛″); W: 22.9 cm (9″)

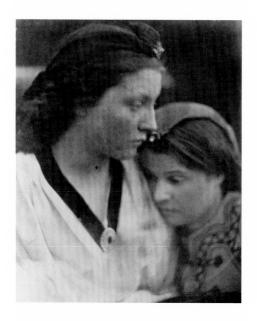

63r (JMC 82)
Confidence/
FreshWater/May 1864
H: 25 cm (9¹³⁄₁₆″); W: 20 cm (7⅞″)

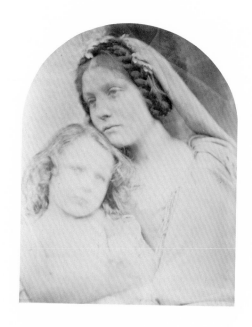

64r (JMC 83)
Mother and Child
H: 24.5 cm (9⁹⁄₁₆″); W: 18.9 cm (7⁵⁄₁₆″)

65r (JMC 84)
The Infant Undine/
FreshWater/1864
H: 27.1 cm (10⅝″); W: 20.9 cm (8¼″)

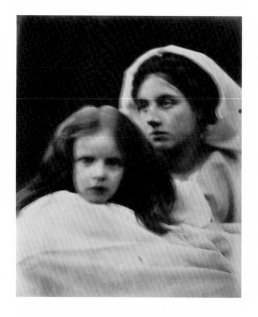

66r (JMC 85)
Aurora/
FreshWater/1864
H: 25.4 cm (10″); W: 19.9 cm (7¹³⁄₁₆″)

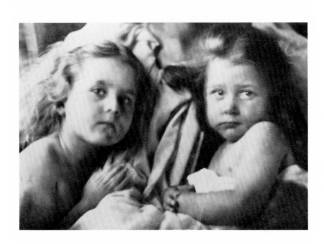

67r (JMC 86)
The bereaved Babes/The Mother moved!
FreshWater/1864
H: 19.6 cm (7 11/16″); W: 14.3 cm (5 5/8″)

68r
The Vision of Infant Samuel
Signed: l.r., *Julia Margaret Cameron*
Rectangular blind stamp: *Registered Photograph…*
H: 24.3 cm (9 9/16″); W: 21.3 cm (8 3/8″)

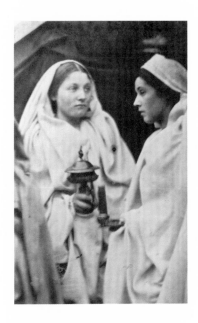

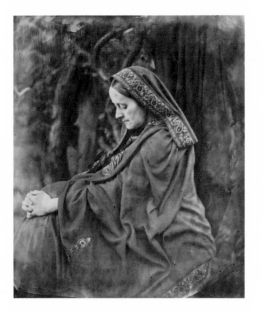

69r (JMC 87)
A Group/
FreshWater/1864
H: 19.7 cm (7 11/16″); W: 12 cm (4 3/4″)

69v (JMC 88)
Lady Elcho/as a Cumean Sybil/
Little Holland House Lawn/1865
H: 26.8 cm (10 1/2″); W: 22.1 cm (8 3/4″)

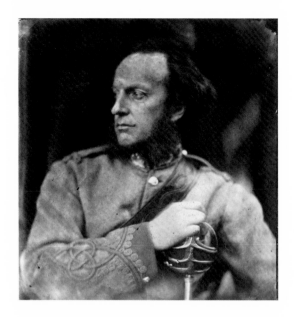

70r (JMC 89)
Lord Elcho/
Little Holland House Lawn/1865
H: 24.7 cm (9¾"); W: 22.6 cm (8¹⁵⁄₁₆")

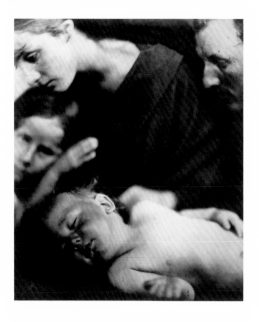

72r (JMC 90)
Prayer and Praise/
FreshWater/1865
H: 28.1 cm (11¹⁄₁₆"); W: 22.7 cm (8¹⁵⁄₁₆")

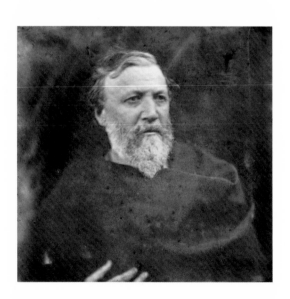

72v (JMC 91)
Robert Browning/
Lawn Little Holland House/May 1865
H: 21.8 cm (8⁹⁄₁₆"); W: 21.8 cm (8⁹⁄₁₆")

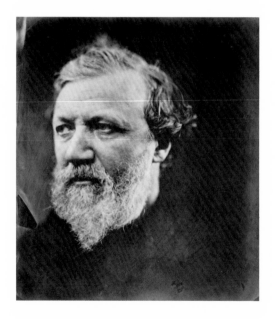

73r (JMC 92)
Robert Browning/
Lawn Little Holland House/1865
H: 25.5 cm (10"); W: 21.8 cm (8⁹⁄₁₆")

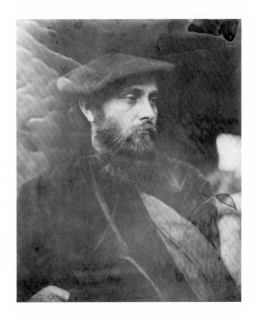

73v (JMC 93)
Wm. M. Rossetti
Lawn L. H. H./1865
H: 24.5 cm (9⁹⁄₁₆″); W: 19.6 cm (7¹¹⁄₁₆″)

74r (JMC 94)
"Seventy Years ago my Darling"/
"Seventy years ago"/The grandmother/real 98/
FreshWater/1865
H: 26 cm (10¼″); W: 21.7 cm (8½″)

75r (JMC 95)
The Whisper of the Muse/Portrait of G. F. Watts/
a Triumph!/
FreshWater/April 1865
H: 26.1 cm (10¼″); W: 21.5 cm (8⁷⁄₁₆″)

75v (JMC 96)
Sir Coutts Lindsay/
L. H. H. lawn/1865
H: 26.7 cm (10½″); W: 22.7 cm (8¹⁵⁄₁₆″)

76r
Julia Herschel
H: 26.2 cm (10¼″); W: 19.5 cm (7⅝″)

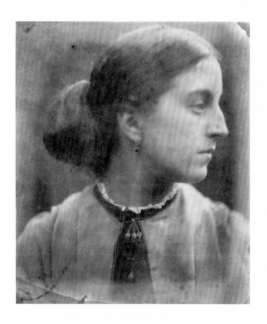

77v (JMC 97)
Lady Adelaide Talbot/
FreshWater [crossed out]/*Little H. H.*
lawn/1865
H: 29.7 cm (11⅝″); W: 24.5 cm (9⁹⁄₁₆″)

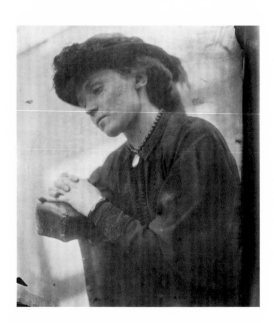

78v (JMC 98)
Minnie Thackeray/
Fresh Water/1865
H: 27.3 cm (10¾″); W: 23.5 cm (9¼″)

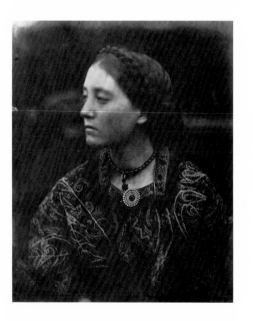

79r (JMC 99)
Annie Hill/
Fresh Water/1864
H: 26.9 cm (10⅝″); W: 20.9 cm (8⁷⁄₃₂″)

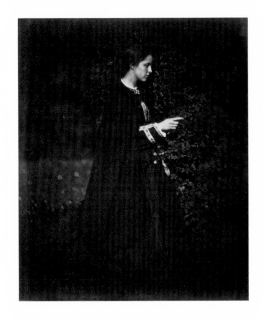

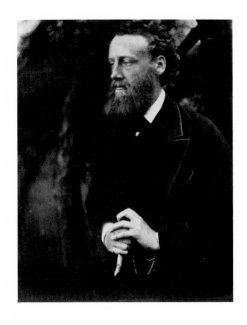

79v (JMC 100)
Magdalene/
L. H. H. lawn/May 1865
H: 27.1 cm (10¹¹/₁₆″); W: 22.1 cm (8¾″)

80r (JMC 101)
Colonel Lloyd Lindsay/
L. H. H. lawn/1865
H: 27.4 cm (10¾″); W: 20.9 cm (8³/₁₆″)

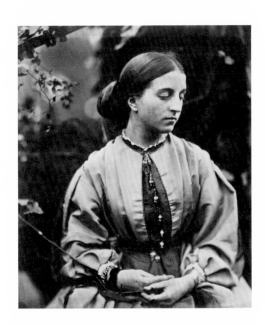

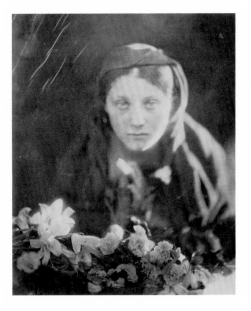

80v (JMC 102)
Lady Adelaide Talbot/
L. H. H. lawn/May 1865
H: 26.3 cm (10⅜″); W: 21.8 cm (8⁹/₁₆″)

81r (JMC 103)
The flower Girl
Fragmentary blind stamp: ... *Messrs*
Colnaghi ...
H: 24.9 cm (9¹³/₁₆″); W: 19.5 cm (7¹¹/₁₆″)

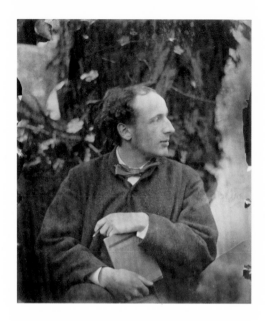

82v
Untitled male portrait
H: 25.6 cm (10 ¹/₁₆″); W: 21.5 cm (8 ⁷/₁₆″)

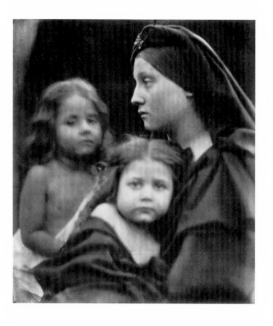

84r (JMC 103)
Trust/
FreshWater/1865
H: 26.2 cm (10 ⁵/₁₆″); W: 21.9 cm (8 ⁵/₈″)

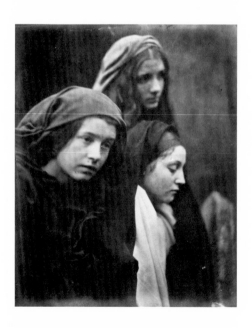

84v (JMC 104)
The three Marys/
FreshWater/1864
H: 27 cm (10 ⁵/₈″); W: 21.6 cm (8 ½″)

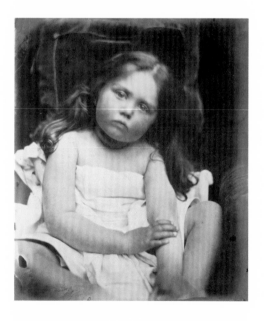

86r (JMC 106)
Alice duCane/
FreshWater/1864
H: 26.6 cm (10 ½″); W: 21.4 cm (8 ⁷/₁₆″)

88r (JMC 108)
J. Strachan Bridges, R. A./
FreshWater/1864
H: 26.4 cm (10⁷/₁₆″); W: 20.5 cm (8¹/₁₆″)

89r (JMC 109)
Water Babies/
FreshWater/1864
H: 24.9 cm (9¹³/₁₆″); W: 21.9 cm (8⁵/₈″)

INDEX OF PROPER NAMES & PHOTOGRAPH TITLES

Names are alphabetized by surname; titles of photographs are alphabetized by the first word or name of the title.

Aged 94 (JMC), *85*

Agnes, Saint, *77, 82*

Alfred Tennyson (JMC), *69*

Alice (JMC), *74*

Alice duCane (JMC), *96*

Alrashchid, Haroun, *55, 57*

Ambrose, Saint, 29

Andrew, Saint, 34

Angel at the Sepulcre, The (JMC), *40, 48*

Angel at the Tomb (JMC), *39, 40, 45, 47, 48*

Annie (JMC), *86*

Annie Hill (JMC), *94*

Anniversary, The (JMC), *70*

Anson, Lady Florence, *25, 48*

Augustine, Saint, 29

Aurora (JMC), *15, 37, 90*

Baring, Sir Thomas, 18

Beatrice (JMC), *41, 58*

bereaved Babes, The (JMC), *31, 91*

Berkeley, George (bishop of Cloyne), 24

Bernardin de Saint-Pierre, Jacques- Henri, 32

Biblical figures

 Ahasuerus (King), 58

 Elizabeth, 37, 49

 Esther, 58

 Jephthah, 58

 Jeremiah, 58

 Jesus Christ, 26, 31, 32, 33, 34, 37, 39, 40, 41, 49, 53, 55

 John the Baptist, Saint, *25*, 31, *32*, 34, 37, 39, 45, 48, 49

 Joseph, Saint, 34

 Joseph of Arimathea, 34

 Mary Madonna, 26, 29, 32, *33*, 34, 37, 42, 48, *88*

 Mary Magdalene, 26, 37, 39, 40, 41, 42, 45, 48, 49

 Matthew, Saint, 39

 Moses, 48, 49

 Rebecca, 26

 Samuel, 34, *88, 91*

Blessing and Blessed (JMC), *78*

Brookfield, Magdalene, 39, *80*

Browning, Robert, 92

Bürger, Gottfried August, 42, 49

Call, I Follow, I Follow. Let Me Die (JMC), 39, *46, 48*

Cameron, Archie, *33*

Cameron, Aubrey, 64, 67

Cameron, Charlie Hay (Charles Hay, Jr.), *14*, 66, 67

Cameron, Charles Hay, 15, 18, 21, 24, 30, 39, 53, *54*, 57, 61, 62, 64, 66, 68, *89*

Cameron, Eugene, 29, *33*

Cameron, Ewen, 63, 64, 65, 66, 67, *86*, 89

Cameron, Hardinge Hay, 30, 61, 64–65, 67, *71*

Cameron, Henry Herschel Hay, *14*, 61, 65, 66, 67

Cameron, Julia, 34

Cameron, Topsy/Birdie, 64, 66, 67

Carlyle, Thomas, *52, 53*, 55

Charles Hay Cameron (JMC), *54, 89*

Christmas Carol, A (JMC), 34, *87*

C. L. Norman (JMC), *83*

Coleridge, Samuel Taylor, 23–24

Colonel Lloyd Lindsay (JMC), *27, 95*

Confidence (JMC), *90*

Contemplation (JMC), *76*

Credi, Lorenzo di, 18

Dalkeith, Lord (William Henry Walter Montagu-Douglas-Scott, Duke of Buccleugh), 66

Days at Freshwater (JMC), *40, 48, 48*

de Vere, Aubrey, *22, 23*, 32

Dickens, Charles, 40

disappointment, The (JMC), *82*

Dolci, Carlo, 18

Domenichino (Domenico Zampieri), 18

Double Star, The (JMC), 31, *35*, 37, *88*

Dream, The (JMC), 39, *40*, 45

Duckworth, Julia, 61, 63

du Maurier, George, 40

Elcho, Lady (Anne Frederica Anson), 37, *72*, 91

Elcho, Lord (Francis Richard Charteris, Earl of Wemyss), 57, 66, 92

Emerson, Peter Henry, 21, 45

Evans, Frederick, 16

Ewen (JMC), *86*

Ewen Wrottesley Hay Cameron (JMC), *89*

Faith (JMC), 34, *77*

Fenton, Roger, 34

first born, The (JMC), *32, 73*

First Ideas (JMC), *86*

Fisher, Herbert, 66

five foolish Virgins, The (JMC), *79*

five Wise Virgins, The (JMC), 37, *79*

Florence/Study of St. John the Baptist (JMC), 25

"Flos and Iolande" (JMC), 37, *51, 86*

flower Girl, The (JMC), 95

Fox Talbot, William Henry, 18

Fra Bartolommeo (Baccio della Porta), 32

Francia (Francesco Raibolini), 32

Gentleness (JMC), 29, 31, *83*

G. F. Watts (JMC), *19, 81, 83*

Goethe, Johann Wolfgang von, 39

Goodness (JMC), 34, *76*

Grace thro' Love (JMC), 29, 34, 48, *75*

Group, A (JMC), 37, *91*

Hamerton, P. G., 21, 57

Handel, George Frederick, 24

Hardinge Hay Cameron (JMC), 71

Hartley, David, 23, 26

Haskell, Sir Francis, 18

Henry Halford Vaughan (JMC), 84

Henry Taylor (JMC), *70, 72,* 79

Herschel, Julia, *81, 94*

Herschel, Sir John, 15, 42, 53, 61

Hillier, Mary, 37, 48, 64

Holbein, Hans, 26

Hooch, Pieter de, 18

Hope (JMC), 34, *89*

Hosanna (JMC), 33, *89*

Hughes, Jabez, 15

Hunt, William Holman, *55, 57, 72, 87*

Infant Bridal, The (JMC), 32, *75*

Infant Samuel, The (JMC), 26, *88*

Infant Undine (JMC), 90

"I promise" (JMC), *81*

Isaacson, Reverend J., *20,* 23, 88

Isabel and Adeline Somers (JMC), 77

Jameson, Anna, 23, 30, 32, 33, 34, 37, 39, 45, 53, 58

James Spedding (JMC), 71

Jerome, Saint, 29

Jowett, Sir Benjamin, 57, 87

"Joy" (JMC), 73

J. Strachan Bridges (JMC), 97

Julia Herschel (JMC), *81, 94*

Keats, John, 26

Keble, John, 23–24, 32, 39

Kingsley, Charles, 23, 30, 31, 49, 53

Kiss of Peace, The (JMC), 37, *38,* 39, 45, 48, 49, 50

Lady Adelaide Talbot (JMC), *94, 95*

Lady Elcho (JMC), *72,* 91

Lichfield, Lord (Thomas George Anson, Earl of Lichfield), 66

Light and Love (JMC), 32, 73

Lilford, Lord (Thomas Atherton Powys, Baron Lilford), 66

Lindsay, Lord, 29

Lionel Tennyson (JMC), 84

Literary figures

 Arthur (king), 26, 57, 58

 Cenci, Beatrice, 39, 58

 Cordelia, 58

 Doasyouwouldbedoneby, Mrs., 31, 40

 Elaine, 39

 Enid, 41

 Flos and Iolande, 37, 41, 45, 48, *51, 86*

 Gretchen, 39

 Guinevere, 41

 Juliet, 58

 Lawrence, Friar, 58

 Lear (king), 58

 Leonora and William, 42, 45

 Maud, 26, 39

 May Queen, The, 42, 45

 Miranda, 58

 Ophelia and Hamlet, 26, 39, 45

 Prospero, 58, 77

 Samson, Abbot, 55

 Vivien, 41

Long-suffering (JMC), 34, *44, 85*

Lord Elcho (JMC), 92

Lord Overstone (JMC), *17*

Lorrain, Claude, 18

Love (JMC), 34, 76

Loyd-Lindsay, Colonel, 26, *27, 57,* 95

Luini, Bernardino, 32

Maclise, Daniel, 42, 49

Madonna Adolorata, La (JMC), 34, 76

Madonna Aspettante, La (JMC), 74

Madonna della Pace, La (JMC), 78

Madonna della Ricordanza, La (JMC), 81

Madonna Esattata, La (JMC), 78

Madonna Riposata, La (JMC), *74,* 79

Madonna Vigilante, La (JMC), 74

Magdalene (JMC), 95

Magdalene Brookfield (JMC), 80

Mary Madonna (JMC), 88

May Queen, The (JMC), 42, *49*

Michelangelo Buonarroti, 16, 58

Mill, James, 23

Mill, John Stuart, 23

Millais, Sir John Everett, 37

Milton, John, 23, 26, 45

Minnie Thackeray (JMC), 94

Mother and Child (JMC), 90

Murillo, Bartolomé Esteban, 18

Mythological figures

 Castor and Pollux, 50

 Hermes (Mercury), 49

 Zeus, 49, 50

Newman, John Henry Cardinal, 23

Norman, Charles, 18, 83

Ostade, Adriaen van, 18

Ostade, Isaak van, 18

Overstone, Lord (Samuel Jones Loyd, Baron Overstone), 15, 16, *17,* 18, 21, 32, 61, 63

Parmigianino (Francesco Mazzola), 18

Paton, Sir Joseph Noel, 30, 31

Paul and Virginia (JMC), 32, 70

Peace (JMC), 75

Penseroso, Il (JMC), 75

Perugino (Pietro Vannucci), 18

Plato, 55

Portrait of Aubrey de Vere (JMC), 22

Prayer and Praise (JMC), 34, *43, 92*

Prinsep, Loo, 67

Professor Jowett (JMC), 87

Prospero (JMC), 58, 77

Pynacker, Adam, 18

Recording Angel, The (JMC), 85

red and white Roses, The (JMC), 73

Rejlander, Oscar, 15

Rembrandt van Rijn, 16, 18, 57

Reni, Guido, 18, 30, 32

Rev. J. Isaacson (JMC), *20, 88*

Reynolds, Sir Joshua, 18, 24

Robert Browning (JMC), 92

Rosa, Salvator, 18

Rossetti, Christina, 42

Rossetti, Dante Gabriel, 31

Rossetti, William Michael, 21, 57, *71, 93*

Ruisdael, Jacob van, 18

Ruskin, John, 26, 39

Sadness (JMC), *82*

Salutation, The (JMC), 15, 37, 84

Sappho (JMC), *80*

Seeley, J. R., 53

Seraphim and Cherubim (JMC), 83

Sesto, Cesare de, 32

"Seventy Years ago my Darling" (JMC), *93*

Shadow of the Cross, The (JMC), 33, *33*

Shakespeare, William, 15, 24, 26, 39

Shunamite Woman and her dead Son, The (JMC), 26, 85

Sir Coutts Lindsay (JMC), *72, 93*

Sisters (JMC), 49

Somers, Lord (Charles Somers-Cocks, Earl Somers), 66

Southey, Robert, 26

South West Wind, The (JMC), *82*

Spring (JMC), 31, 34, *80, 82*

St. Agnes (JMC), *77, 82*

Steen Jan, 18

Stirling-Maxwell, Sir William, 18

Story of the Heavens, A (JMC), 49, *50*

Stubbs, George, 18

Study for "Maud," A (JMC), *40*

Study—Madonna (JMC), *33*

Suspense (JMC), *84*

Taylor, Sir Henry, 16, 23–24, 26, 30, 37, 58, 61, 66, *70, 72,* 79

Tennyson, Alfred Lord, 15, 26, 39, 42, 55, *55,* 57, 58, 69

Terry, Ellen, 40

Thomas Carlyle (JMC), *52*

Thompson, J., 49, 55

three Marys, The (JMC), *36,* 96

Titian (Tiziano Vecellio), 16, 18

Trust (JMC), 29, *96*

Velde, Willem van de, 18

Verstolk, Baron, 18

Vision of Infant Samuel, The (JMC), 33, *91*

Water Babies, The (JMC), *78, 97*

Water Babies again (JMC), 87

Watts, George Frederick, 15, 16, *19,* 21, 24, 33, 40, 45, 57, *81, 83*

Weyden, Rogier van der, 34

Whewell, William, 42

Whisper of the Muse, The (JMC), 57, *93*

Wm. Holman Hunt (JMC), *72, 87*

Wm. M. Rossetti (JMC), *71, 93*

Woman with Hand to Head (JMC), *41*

Wordsworth, William, 23–24, 26

Wright, Thomas, 58

Wynants, Thomas, 18

Wynfield, David Wilkie, 15

Selected Bibliography

C. H. Cameron, *Two Essays* (London, 1835).

Colin Ford, *The Cameron Collection* (London and New York, 1975).

Helmut Gernsheim, *Julia Margaret Cameron: Her Life and Photographic Work* (Millerton, 1975).

Margaret Harker, *Julia Margaret Cameron* (London, 1983).

Brian Hill, *Julia Margaret Cameron: A Victorian Family Portrait* (London, 1973).

Anna Jameson, *Legends of the Madonna* (London, 1852).

——, *The Poetry of Sacred and Legendary Art,* 9th ed. (London, 1848).

Joanne Lukitsh, *Cameron: Her Work and Career,* ex. cat. (Rochester, International Museum of Photography at George Eastman House, 1986).

D. P. O'Brien, ed., *The Correspondence of Lord Overstone* (Cambridge, 1971).

Graham Ovenden, ed., *A Victorian Album: Julia Margaret Cameron and her Circle* (London, 1975).

Mike Weaver, *Julia Margaret Cameron, 1815–1879* (London and Boston, 1984).

Editor: Andrea P. A. Belloli

Designer: Patrick Dooley

Typeset in Berthold Sabon by Mondo Typo, Santa Monica

4,000 copies were printed on Karma natural
by Gardner/Fulmer Lithograph,
Buena Park

Binding and stamping by Roswell Bookbinding, Phoenix

All photographs of objects in the J. Paul Getty Museum
by Stephenie Blakemore
assisted by Rebecca Vera-Martinez.